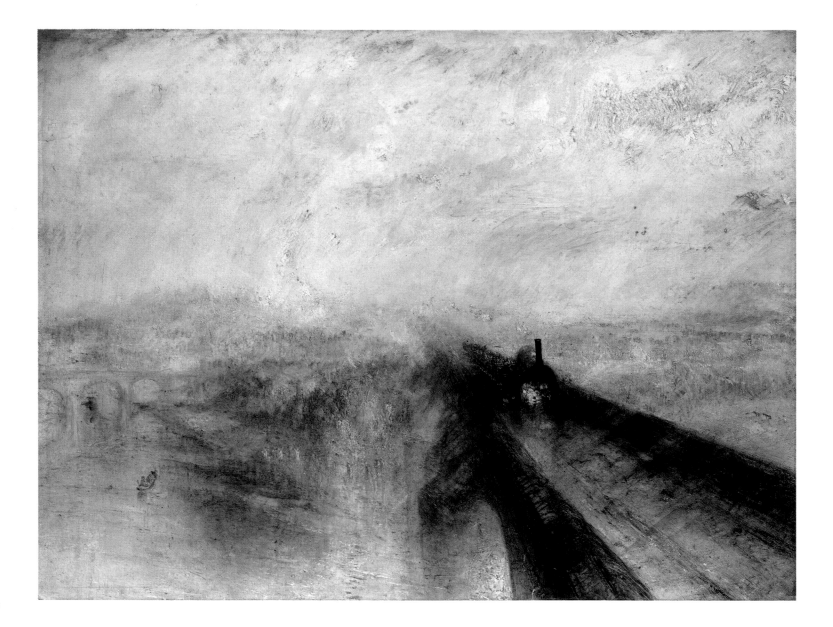

Michael Bockemühl

J.M.W. TURNER

1775–1851

The World of Light and Colour

Benedikt Taschen

FRONT COVER:
Detail from: *Peace – Burial at Sea,* 1842
Oil on canvas, 87 x 86.5 cm
London, The Tate Gallery (cf. illus. p. 72)

FRONTISPIECE:
Rain, Steam and Speed – The Great Western Railway, 1844
Oil on canvas, 90.8 x 122 cm
London, The National Gallery

BACK COVER:
Self-portrait, 1799
Oil on canvas, 74.3 x 58.5 cm
London, The Tate Gallery

© 1993 Benedikt Taschen Verlag GmbH
Hohenzollernring 53, D-50672 Köln
Edited and produced by Sally Bald
Picture research by Frigga Finkentey, Cologne
Cover design by Angelika Muthesius, Cologne
English translation by Michael Claridge
Printed by Druckhaus Cramer GmbH, Greven
Printed in Germany
ISBN 3-8228-0554-8
GB

Contents

Observation – a method of approach

"If the totality of colour is presented to the eye from the outside in the form of an object, it will be pleasing to the eye, because it thereby encounters the sum of its own activity as reality." Turner's marginal comment: "-this is the object of Paintg [painting]".
(Goethe, *Theory of Colours*, §808, HA, vol. 13, p. 502)

J.M.W. Turner is numbered among those artists granted a long period of creativity. He worked tirelessly for over sixty years; his estate alone embraced more than 19,000 drawings and colour sketches, while the range of his output, covers a broad span. It is only with difficulty that we can identify the pages produced by the young artist around 1790 – the closing years of the Rococo – as the work of the artist from whom would come the brilliant, free weaving of colour found in the pictures painted in the 1840s. Not until his later works did he find a style of painting all his own, a vision of nature hitherto impossible. Even today, his later pictures can give the observer a sense of seeing the world for the first time – a world of colour and light.

As early as 1843, John Ruskin, the most influential British art critic of Romanticism and the first passionate defender of Turner's painting, expressed the opinion in his "Modern Painters" that Turner's pictures enabled one to see the world in a new way: "The whole effect of painting from the technical viewpoint is based on our ability to acquire once again that state which one could call the *innocence of the eye*, in other words a way of looking at things in a childlike manner, through which one perceives spots of colour as such without knowledge of their meaning – as a blind man would see them if his sight were restored all of a sudden".[1] Yet it is this power to change our vision that renders Turner's painting a puzzle even today. This applies not only to the dating of his works – which is especially difficult in a number of cases – or to the efforts of art historians to place his pictures' motifs within the context of the artistic development of the first half of the 19th century. "I did not paint it to be understood," Turner objected, following scathing criticism of one of his later, significant pictures, "but I wished to show what such a scene was like".[2] His later painting was intended exclusively for the eye. The possibilities of vision offer not only particular access through the act of observation to the depictive quality of nature but also, equally, fresh access to the nature of the picture. The highly persuasive quality of his art appears substantiated precisely by the impossibility of separating the one from the other. His painting defines anew the relationship of nature and art.

Extensive research has been conducted into Turner's life, enabling the wealth of his creative output to be placed in perspective. The question remains, however, as to how he developed a style of painting through which both nature and art could reveal themselves in a new way. A conscious understanding of the complex effect produced by Turner's pictures requires one to take into consideration a multitude of factors. This effect is anything but a matter of course. It presupposes a complex interaction of creative possibilities in art, something which he achieved through various means in the course of his creative activity. His later pictures are intended purely for the eye, and their comprehension depends on a conscious understanding of the manner in which they disclose themselves to the eye. It is thus necessary to examine the creative elements interacting here, to take notice of their effect upon the observer.

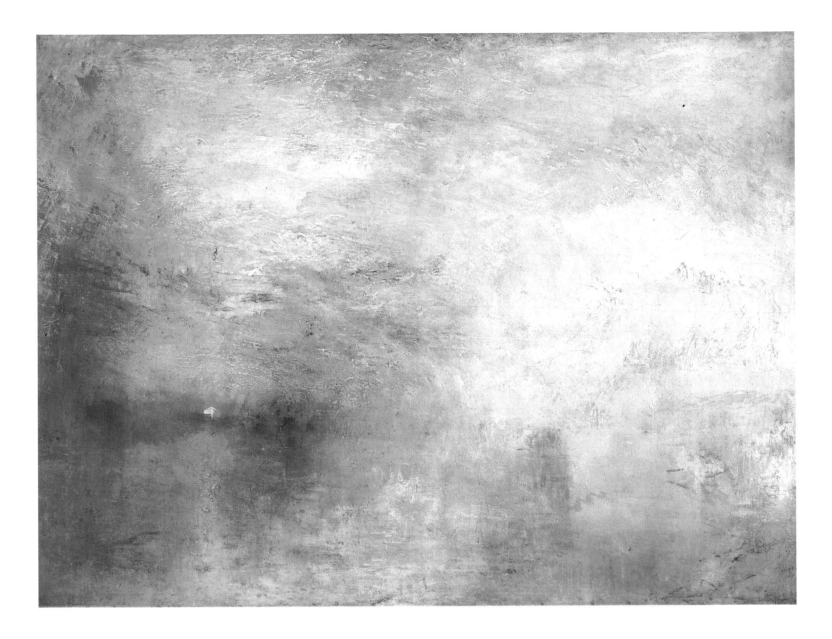

Turner's work cannot be reproduced. Even the best print only serves to awaken one's curiosity about the original. The fundamental significance attached both to nuances of colour and structure and to the fine differences between the traces of pen or brush, whether pronounced or merely fleetingly applied, is particularly great in the context of Turner's art. The immediacy of the often exceptionally fine glazing layers of colour, of the fleeting or striking nature of the drawings, can only be observed directly from the material. This may take the form of paper, as used in the sketches, sometimes given a preliminary coating, subsequently scratched out with a thumbnail, intentionally crumpled up and smoothed out again, and often rolled up in a portmanteau; or we may be concerned here with the surfaces of the original oil paintings, given a pastose or glazed treatment such as would mock any pattern. However, the observational nature of the pictures cannot reveal itself unless the observer allows himself to become actively involved. Ultimately, this nature cannot be communicated – especially verbally. The observer must himself become active. In following the attempt of this study to grasp – if only at an initial level – this effect on the observer of Turner's work, he will be unable to avoid a growing consciousness of his own observational activity, together with an awareness that this is an integral element of these pictures. The following descriptions lead in this direction.

We are concerned here with an attempt at an approach to Turner's art, to stimulate the reader to *see* Turner's pictures for himself.

Sun Setting over a Lake, c. 1840
Oil on canvas, 91 x 122.5 cm
London, The Tate Gallery

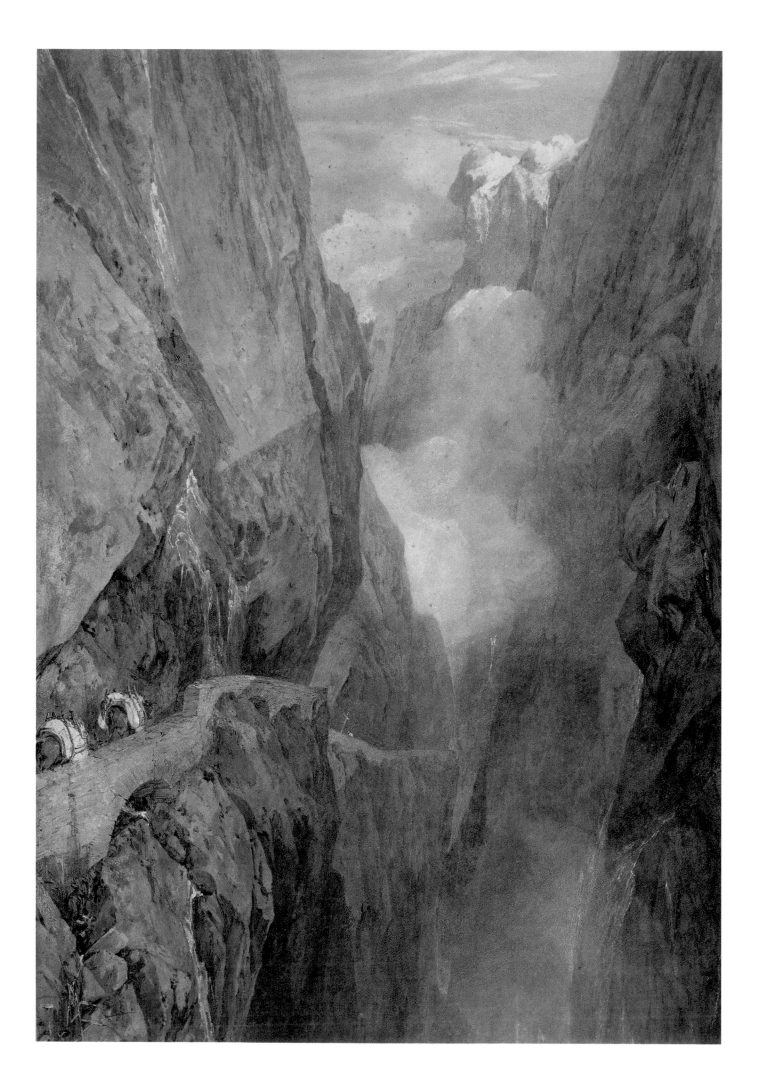

Early days – expertise becomes evident

Turner's extraordinary talent was discovered while he was still young; his parents, unlike those of many other artists, were proud of the fact. Mary, his mother, who was later to die in an emotionally disturbed state in a nursing home, was the grand-daughter of a butcher. His father, who in the latter part of his life would take on the manservant's role in the painter's bachelor household, not only preparing the paints but also mounting and grounding the canvases, was a barber and wig-maker; he displayed the twelve-year-old's drawings in his shop window and also sold them. Some of these have survived, including a number in imitation of the landscape engravings common at the time. At the age of fourteen, young William was able to escape in summer from the lanes of Covent Garden, narrow enough at that time, and visit his uncle in the country near Oxford. It was at this early stage in his life that he began something which was to be his habit for the rest of his life, roaming through the countryside and making sketches. The result was his first sketchbook.

Various architects, their attention caught by his skill, commissioned drawings from him. He was required to produce sketches of buildings in perspective, surrounding them with the appropriate scenery and colouring them. As a result, Thomas Malton, one of the better-known topographical draughtsmen of the day, took him on as his apprentice, and he was admitted to the art school of the Royal Academy on a probationary basis. All this occurred within the space of one and the same year.

It was only a year later that the Royal Academy first displayed a Turner picture, a watercolour, in its annual exhibition, an event as important for the British art world as the Paris Salon for its French counterpart. Two pictures were displayed in 1791, and he was to contribute to almost every Academy exhibition that was organized in the course of the following sixty years. At the age of seventeen, he attended the art school's "Life Academy", where he drew from the nude model; the following year, he was awarded the "Greater Silver Palette" for landscape drawings. At the age of twenty-one, he was able to present not only watercolours but also his first oil painting in the Royal Academy (p. 24). He was elected Academy Associate in 1799; in 1802, he attained full membership, something he had long sought; voted onto the Council soon after, he was appointed Professor of Perspective to the Academy five years later in recognition of his achievements.

It was first of all as a draughtsman that Turner acquired recognition. His precise perspective, for example in the early work *Cathedral Church at Lincoln*, and the realism with which the actions of the characters are portrayed in the 17-year-old's coloured drawing *The Pantheon, the Morning after the Fire* - famous for its depiction of the figures – show a masterly hand already at work in their sketching of outlines and shadows, and characteristic, generally humorous faces.

Turner's summer walking tours led him through the various counties as far as

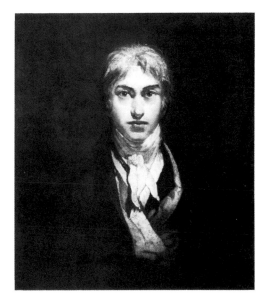

Self-portrait, 1799
Oil on canvas, 74.3 x 58.5 cm
London, The Tate Gallery

The Passage of the St. Gothard, 1804
Watercolour with scraping-out, 98.5 x 68.5 cm
Kendal, Cumbria, Abbot Hall Art Gallery

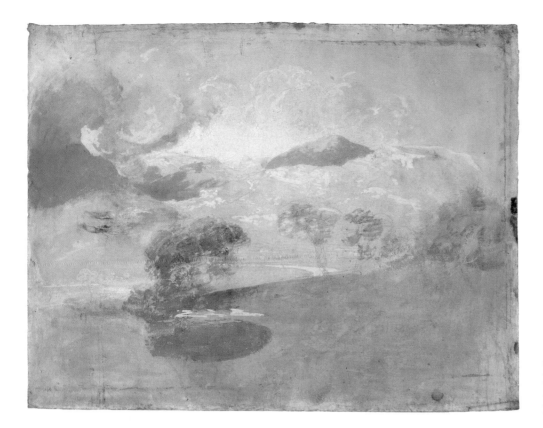

View towards Snowdon from above Traeth Bach,
with Moel Hebog and Aberglaslyn?, 1789–90
Pencil and watercolour with scraping-out,
66.4 x 85 cm
London, The Tate Gallery

Scotland. He prepared himself by studying guidebooks, making a note of the places
which he wanted to draw.[3] Travel reports and guidebooks containing pictures were
very much in demand at the time, with the first "tourists" setting forth on their
travels. The first "illustrated" magazines were also achieving increased circulation
figures, a typical example, starting with the title, being the series of etchings – parks,
country houses, churches, ruins – by Turner's teacher Thomas Malton, *Pituresque*
Tour through London and Westminster, published in 1792. Even Londoners were inter-
ested in seeing their own surroundings depicted as the reason for a journey, as some-
thing worth seeing. Turner increasingly arranged his trips to coincide with commis-
sions for travel-report illustrations. He undertook a journey to Kent and Sussex for
John Walker's "Copper-Plate Magazine", completing 32 pictures for this project
alone in a very short time. Purchasers, patrons and sponsors presented themselves. Sir
Richard Colt Hoare invited him to Stourhead, the park of which was laid out in the
manner of paintings by Claude Lorrain – a landscape rearranged in accordance with
and imitating art. Colt Hoare engaged him to draw the town and cathedral of Salis-
bury. A steel manufacturer asked him to draw his steel-works in Cyfarthfa. He be-
came acquainted with Walter Ramsden Fawkes and the third Earl of Egremont,
both of whom were later to invite him to their country seats, where the artist prob-
ably spent the happiest days of his life. Petworth House in particular, Lord Egre-
mont's mansion, would become Turner's inner home, his sanctuary, in later years.

We may gauge the extent to which he was sought after among other things
from the negotiations in which he was involved with Lord Elgin, who wished to
take the artist with him on his expedition to Greece; the Elgin Marbles constitute
the principal works of the Greek classical period on display in the British Museum.
Turner demanded a high fee; since he also refused to forgo the copyright on his
drawings, they were unable to come to an agreement. Turner was receiving an in-
creasing number of requests to provide the illustrations for anthologies and collec-
tions of poetry, and was already well-known in France and Germany as a result of his
vignettes for works by Walter Scott, Lord Byron and Samuel Rogers, even then

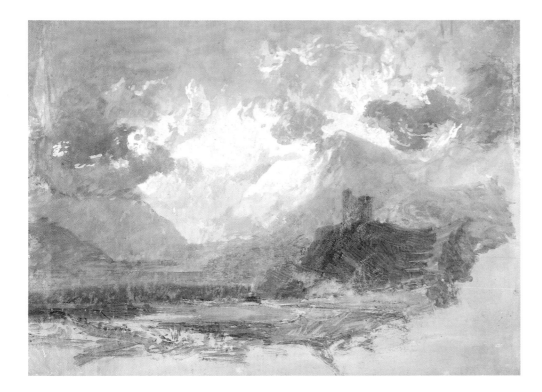

Dolbadern Castle, c. 1799
Pencil and watercolour, 67.7 x 97.2 cm
London, The Tate Gallery

most-noted among the Romantics. Turner soon developed a style all his own for his vignettes; indeed, they may be seen as one of the highpoints of book illustrating. For the time being, however, the young artist was valued for his gift of depicting what he saw. This was regarded as progress – as a conquest of reality – by British collectors, whose number included manufacturers and bankers. Indeed, a basic desire for realistic depiction was not the least element that would contribute greatly to the development of photography in Turner's own lifetime.[4]

Turner's inclination to depict nature was not the only guiding force for his talent and interest. At the age of nineteen, he was prompted to devote his attention to the masterworks of landscape painting through the influence of Dr. Thomas Monro, the physician, who concerned himself with fostering young talent. Whole series of sketches after Richard Wilson and the Frenchman Claude Joseph Vernet, who was highly esteemed in Britain at that time, can be found in his sketchbooks. The teachings of Joshua Reynolds were also formative; Turner met him at the Royal Academy, where his teachings were promulgated. His early artistic course was further influenced by Edmund Burke's reflections on the Sublime and the Beautiful. Landscape painting, it was stated, should focus on what is infinite, overwhelming, heroic, on unconquered, alien nature, before which man stands in fear and amazement – in short, on the Sublime. However, the Academy at the time of Turner's apprenticeship also continued to recognize the principles of William Gilpin, the engraver and writer, who considered the quality of a landscape painting to be founded above all else in the "picturesque". In Burke's theory, the "smooth" was determined as an essential characteristic of the Beautiful; Gilpin, in contrast, had accorded the "rough" an artistic appeal.[5] This led ultimately to the development of a kind of canon of picturesque props – old ruins, moss-covered rocks, towering cliffs, waterfalls, bizarre trees, old mills or stables, along with country people, shepherdesses, ragged children, wayfarers. These could then be grouped together in a sequence of foreground, centre and background, one which had become equally traditional in landscape representation.

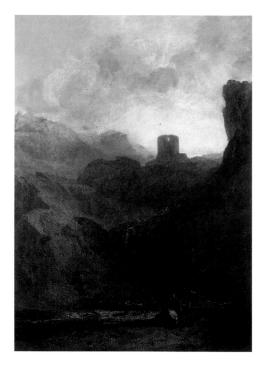

Dolbadern Castle, North Wales, 1802
Oil on canvas, 119.5 x 90.2 cm
London, Royal Academy of Arts

Landscape painting, or what was recognized as such in Turner's initial years as an artist, thus concerned itself only to a very limited extent with the direct observation of nature. Only an artist of drawings and watercolours, one who did not have to compete with the great works of art, was free to demonstrate such exactness in depiction, to produce scenes of such great spontaneity for his day and age, as did Turner; being of a lower profession, he found himself somewhat outside the traditional limitations. However, this evaluation was to change, not least through the work of Turner himself. In those days, landscapes were seen as a genre for painters who had decided to specialize in landscape painting. At the core of Reynolds' teaching lay the constantly repeated advice to the artist to distinguish clearly between the various categories and then – to the satisfaction of all concerned – to move solely within the boundaries of a genre which were within his ability, rather than to make excessive demands upon himself in striving for that which was higher – history painting in Reynolds' case, which he himself represented. The distinction was made between architectural representations, town views, mountain scenes, pastoral landscapes or the arcadian idyll, the aforementioned heroic landscape with a representation of catastrophes, or historic events, and – not least – seascapes: marine paintings, shipwrecks, shore scenes and suchlike.

In 1799 came Turner's decisive encounter with the paintings of Claude Lorrain in the Angerstein Collection. It is said that Lorrain's *Seaport with the Embarkation of the Queen of Sheba*[6] moved him to tears. It would appear to be Claude's paintings which first led him to discover the possibilities of forming light through painting. The colourful brightness, the pastel shades, the concentration upon the effect of light alone, the unobstructed view of the sun as so often depicted by Claude – all this, Turner felt, was inimitable. He believed that he would never be capable of painting such a picture.[7]

The Treaty of Amiens in 1802 gave the artist his first opportunity to travel to the Continent, a journey undertaken by many British artists at this time. His first destination was Switzerland, the encounter with a totally alien nature, one still barely accessible in those days. On his way back, he spent an extended period in Paris visiting the Louvre. As a result of Napoleon's conquests, the art collection had been enlarged by many extremely valuable items. Turner devoted his attention to an exhaustive examination of Poussin, Titian, Rembrandt and Salvator Rosa. He studied the distribution of colours; his sketchbooks reveal outlines into which he wrote the respective shades in abbreviated form. His particular attention was focussed upon style, however, upon the use of chiaroscuro, upon the manner in which colours were employed. He noted down observations and evaluations. He was to paint pictures in the style of various great masters now and again up to the mid-thirties, occasionally not only adopting a particular style of painting but even making the artist in question the hero of the scene that was being depicted. These studies include one that pays homage in amusing fashion to Jan van Goyen, and also a Watteau study.[8] Back from his first journey to Rome, he immediately quoted the style of Raphael's architectural vistas, linking this with a fictitious scene depicting Raphael, accompanied by La Fornarina, preparing to decorate the loggia with his paintings (p. 31).

It can be assumed that Turner was not especially concerned in this and the other scenes with historical accuracy. He attached greater significance to the narrative attraction of the episode, something which allowed him to join together the "Raphaelesque" – and simultaneously so "Turnerlike" – figures in front of the town floating in the evening light so as to form a contemplative mood – a kind of game involving the picture in the picture.

It should be observed that such borrowings or echoes were by no means a source of displeasure for Turner's contemporaries. Rather, it was appreciation which

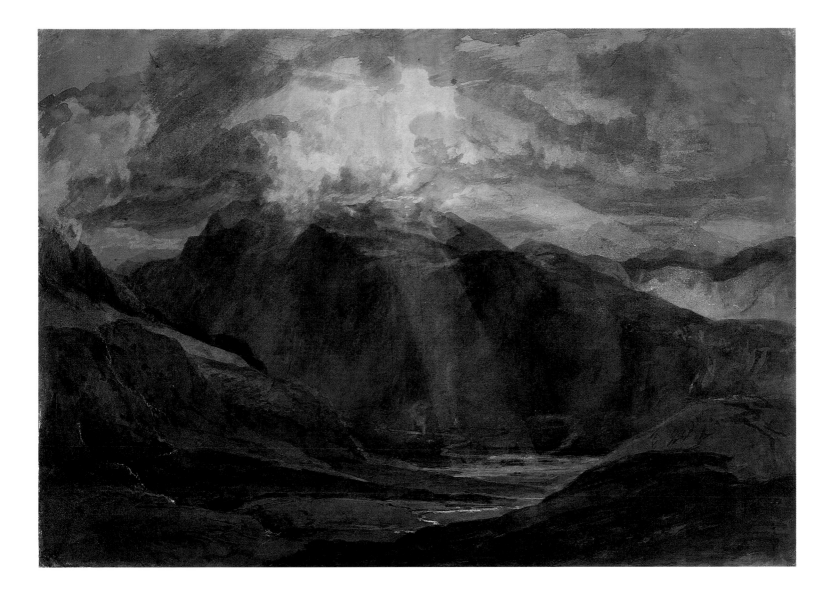

Llanberis, 1799–1800
Watercolour, 55.3 x 77.2 cm
London, The Tate Gallery

was being expressed when, for example, it was noted that his well-known "Bridge-water Sea-piece", *Dutch Boats in a Gale: Fishermen endeavouring to put their fish on board*, was taken from a painting by the Dutch painter Ludolf Backhuysen. At that time, moreover, echoes were observed and positively evaluated such as would hardly suggest themselves today.[9] The painter Benjamin West, for instance, was quoted as saying about the aforementioned picture that it was "what Rembrandt thought of but could not do", while Fueseli, who was also a member of the Academy, is said to have commented on this picture that it was "totally Rembrandtesque".[10] *The Fall of an Avalanche in the Grisons* (p. 15) is constantly associated with the landscape painter Philip-James de Loutherbourg, who was appointed to the Royal Academy in 1781 and had already experimented with the depiction of all-round panoramas.

It may be supposed that such remarks intimated to the ambitious artist the wish that he match himself against every predecessor and contemporary he could think of, thereby to prove that he had mastered their rules and show the Academy that his expertise was every bit their equal. After all, anecdotes suggest that his simple background and frequently brusque and abrupt manner often played a part in controversies with his colleagues and their friends among the art connoisseurs.[11] Furthermore, every now and again he would proclaim his intention to teach. However, all these motives no longer apply in the context of his later art; and more can be seen in such thorough preoccupation with the works of other masters than mere interest in personal self-presentation and instruction. Turner made use of similarities in form or

content as a means of expression, something entirely suited to his time, corresponding to the common practice of travesty in poetry and music – one need think only of the German *Anakreontiker*, the Romantics and their ballads, or Mozart's fantasias and fugues in the style of Bach. In some works, however, it is a question not of simple "adoption" but rather of sympathetic creation, of genuine attunement, of assimilation and subsequent metamorphosis. Of the associations which Turner had, the deepest appears to have been that to Claude. He bequeathed his painting *Dido building Carthage* (p. 23) to the recently founded National Gallery on the condition that it be hung alongside Lorrain's *Embarkation of the Queen of Sheba* (p. 22) – as it may be seen there today. The depth to which Claude's style of painting had moved him, and also his suspicion that he would never be capable of creating its like, have already been indicated. This early encounter with such painting must have stimulated something in Turner towards which he was himself disposed, something for which he was searching, something which opened his gaze to that which was later to be portrayed.

It is through this manner of artistic assimilation and subsequent metamorphosis that his exceptional ability to let coloration, composition, brushwork and so forth come together in the subject being treated is revealed. The intensity with which he progressed through these various styles in no way hindered him from finding his own. The differentiation demanded of him in this "study" contributed to the extraordinary diversity of his means of expression, something which he could almost effortlessly use as he wanted, and also contributed to the great agility and virtuosity so characteristic of his manner of painting. In addition, it should be noted that scarcely any of the pictures fail to reveal his hand, despite any efforts at conformity.

Following his appointment as Professor, Turner let some years pass before beginning his lectures on perspective. The preparations seemed to have no end. The subject did not only involve the rules of linear perspective but also embraced every possible problem of spatial representation. An important chapter was devoted to the so-called aerial perspective, based upon Leonardo da Vinci's observation that distant objects in a landscape take on a bluish hue as a result of the opaque nature of the atmosphere. Turner's lectures were also characterized by the detailed way in which he treated the question of the manner in which the background of a depicted scene was to be structured. It is possible in many respects to link the later pictures to the style in

Glacier and Source of the Arveron, going up to the Mer de Glace, 1803
Watercolour, 68.5 x 101.5 cm
New Haven, Yale Center for British Art, Paul Mellon Collection

which the landscape backgrounds of his earlier oil paintings were executed. However, his lectures tended to be rather theoretical in nature. The initial interest displayed by his audience soon vanished. As the years passed, the only people to attend regularly were Turner's father and a few connoisseurs who appreciated the perfection of the artist's illustrations, which he had painted especially for the lectures. It is typical of his work that it is precisely Turner who in his later pictures disregards every rule governing perspective other than the effect of colour alone. Moreover, if it is possible to speak of the scientific perspective being "overcome" by Cézanne at the end of the 19th century[12], then Turner was one of the first to radically call it into question.

Some years before he took up his lectures at the Academy, however, Turner had formed the intention of producing a textbook, which he heralded as the "Liber Studiorum", following the example of Claude Lorrain's "Liber Veritatis". It was his intention to demonstrate through one hundred examples the possibilities and requirements present in the depiction of various landscape types. The cover shows a densely filled scene, with banners rich in historical association, weapons, overflowing baskets, fish and ancient ruins piled up in front of a medieval arcature and surrounding a magnificently framed central cartouche – a "Rape of Europa".[13]

Turner made use of previous works which had proved successful, but also produced many specifically for this collection of examples, which were then etched by

The Fall of an Avalanche in the Grisons
(Cottage destroyed by an avalanche), 1810
Oil on canvas, 90 x 120 cm
London, The Tate Gallery

Caspar David Friedrich
The Polar Sea (The foundered "Hope"), 1823–24
Das Eismeer (Die gescheiterte "Hoffnung")
Oil on canvas, 96.7 x 126.9 cm
Hamburg, Hamburger Kunsthalle

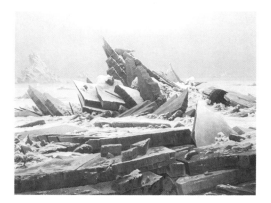

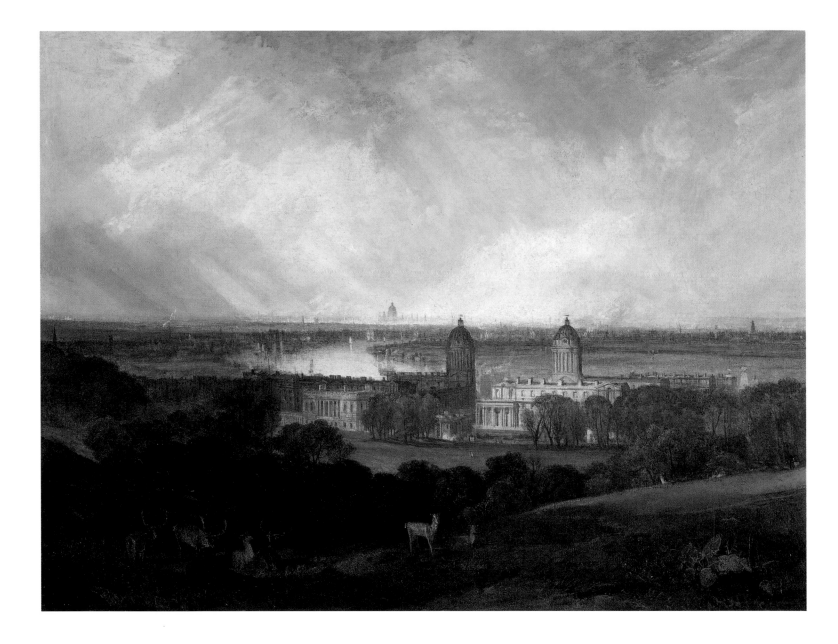

London, 1809
Oil on canvas, 90 x 120 cm
London, The Tate Gallery

various engravers; particular mention should be made here of his old colleague Charles Turner. The aquatint which Charles Turner made of the painting *The Ship-wreck* (p. 25) sold particularly well. However, the textbook remained uncompleted, the later annual instalments failing to appear; furthermore, the author of this compendium refused to apply to himself any methods of composition and painting such as would impose a measure of system. Joseph Farington, who considerably fostered Turner's career at the Academy, noted that Turner rejected every kind of fixed system in drawing and every particular fashion, since "He thinks it can produce nothing but manner and sameness".[14]

In later years, Turner himself was no mean expert in etching, and could give the engraver useful advice. He also often undertook the correction of engravings himself.

However much Turner was appreciated for his drawings of landscapes, it was in the field of oil-painting that he had to fight for an artistic style of his own. First of all, the young painter was required to register his claim to mastery through the required "Academy pieces". The manner of assessment given these paintings – which, after all, were accepted as masterpieces – is particularly significant. Despite his progressive gift in observing nature, fault was found on account of the view that the paintings concentrated more upon sensational than upon accurate "records";[15] moreover, his

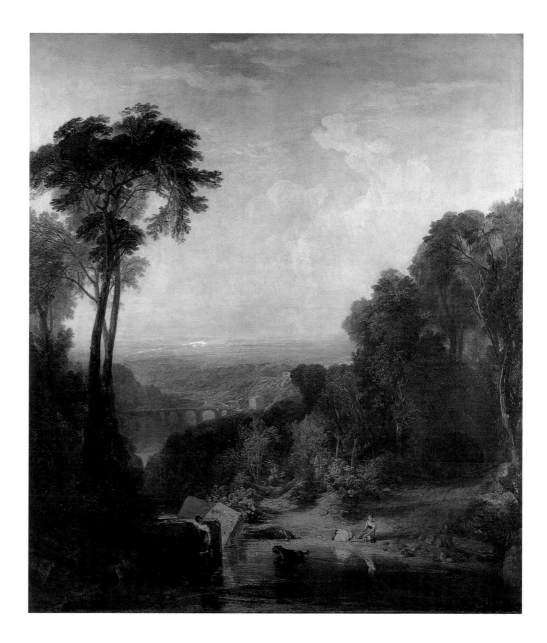

Crossing the Brook, 1815
Oil on canvas, 193 x 165 cm
London, The Tate Gallery

foregrounds were adjudged too undefined, like "blots"; the water appeared as if it were stone; and the pictures were "too much compounded of Art & had too little of Nature". When Turner opened his own gallery in 1804 and his own creative direction began to assert itself, it was only to be expected – despite all his efforts to adhere to tradition – that he would be met with the reproach of not following tradition closely enough.[16] His early masterpieces, covering the entire spectrum of landscape types mentioned in the "Liber Studiorum", are characterized by a tension between depictive realism and pictorial convention, and he included some of them in his textbook collection. As a starting-point for his own style of painting, they reveal at the same time the artistic problems which Turner had to overcome.

London (from the park of Greenwich Hospital, 1809) (p. 16) is a typical example of an architectonic landscape, a landscape portrait of the city of London. It is readily apparent that Turner was concerned to master the broad span of a landscape, the view over a complete city, along with the wealth of detail that it incorporated. Attempts to portray a wide-ranging view in its entirety had reached a peak during the first half of the 19th century. Turner's colleague Thomas Girtin, for example, produced a large-format all-round panorama as early as 1800, while an all-round panorama of London as seen from St.Paul's Cathedral was projected in a dome in Regent's Park in 1829[17]; such an all-round beach panorama can be seen in

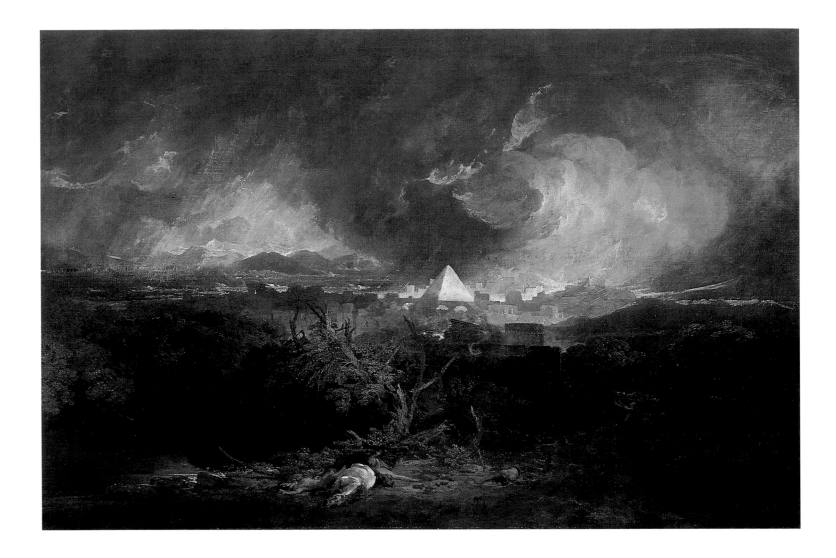

The Fifth Plague of Egypt, 1800
Oil on canvas, 124 x 183 cm
Indianapolis, Indianapolis Museum of Art
(Gift in Memory of Evan F. Lilly)

Scheveningen to this day, the foreground containing "genuine" sand-dunes piled high with flotsam and jetsam. This realism – actually a form of consistent illusionism – was not to be surpassed. In searching for an artistic solution, Turner passed over the recently discovered and publicly admired processes of reproduction. A city panorama which was nonetheless to meet the expectations of the time required an analytical ability on the part of the painter such as could hardly be overestimated. Accordingly, a viewpoint had to be selected which would unite those buildings such as were characteristic for the cityscape. In order to create the impression of an in-depth spatial, atmospheric expanse, the painter was required to concentrate and shorten the countless particulars, bringing out their characteristic features. Turner places some of the palace in the foreground and parts of the distant river-bank in shadow. Clouds, haze and the smoke from the chimneys are executed with the utmost delicacy. The essential elements are seen from a distance, the artist not so much depicting them as providing the observer with indications by means of which they may be inferred. The drawing clearly delineates the palace in great detail in the centre, while the fine, precisely placed marks of the brush in the background enable a kindling of the imagination to produce the illusion of concreteness, despite the fact that its outline is no longer quite complete in the drawing. From a representational viewpoint, the hazy quality of the atmosphere veils the clear – and thus totally accurate – view over the roofs of houses, church steeples, domes, bridges, ships' masts, and so on. Incidentally, Turner mentioned this atmospheric haze in the verses accompanying the picture in the exhibition; here in the painted picture, however, it can only be made comprehensible by means of a deliberate "blurring" of detail and an altered, unifying

coloration, running contrary to the expectations produced by the foreground view. Such a coloration was to be a characteristic of Turner's later work; here it is still a depictive necessity.

The seascape *Fishermen at Sea* ("The Cholmeley Sea Piece") (p. 24) was the first of Turner's oil paintings to be exhibited in the Academy. This nocturnal scene reflects Turner's interest in depicting different manners of illumination; strictly speaking, the depiction, as seen in this painting, stems not so much from a direct observation of nature as primarily from the technical means presented by painting, in the sense of a study of light and dark. The restrained coloration of the "Egremont Sea Piece", *Ships bearing up for Anchorage*, also points to the Netherlands tradition. The first signs of an encroachment upon the classical depiction of space in the sequence of foreground, centre and background, which Turner had demonstrated so faithfully in his first oil painting and was later to completely explode, are already visible in this work.

His seascapes soon took on the character of *plein-air* paintings – paintings produced not in the studio but directly in outdoor daylight; at that time, a seascape painter was expected to make his observations directly by or on the water.[18] Turner fashioned the scene presented in *Calais Pier* (pp. 26/27) from his own experiences while landing in Calais on his first journey to the Continent. The relevant scene is to be found in his sketchbook, together with the comment, "nearly swampt". Such depictions must have had a particular attraction in the eyes of those of his contemporaries who had themselves experienced such situations, yet here too a closer examination reveals an absence of strictly naturalistic "reproduction". The wildly turbulent scene is anything but accidental: it reveals a manner of integration that conclusively

The Bay of Baiae, with Apollo and the Sibyl, 1823
Oil on canvas, 145.5 x 239 cm
London, The Tate Gallery

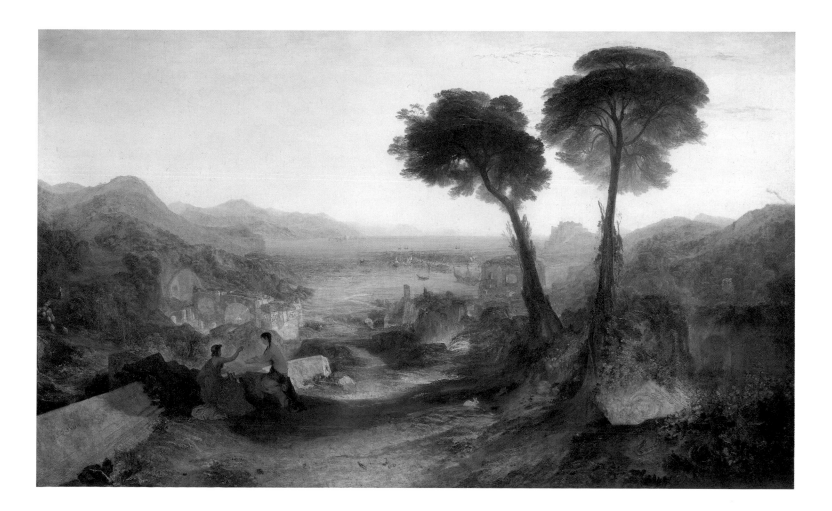

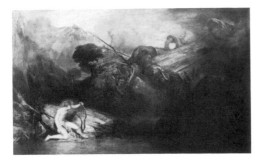

Apollo and Python, 1811
Oil on canvas, 145.5 x 237.5 cm
London, The Tate Gallery

"Envenom'd by thy darts, the monster coil'd
Portentous horrible, and vast his snake-like
form:
Rent the huge portal of the rocky den,
And in the throes of death he tore,
His many wounds in one, while earth
Absorbing, blacken'd with his gore."
(Hymn of Callimachus)

Progress proof of the title page for
the *Liber Studiorum,* 1812
Etched outline with brown ink and wash,
21.3 x 28.4 cm
London, The British Museum

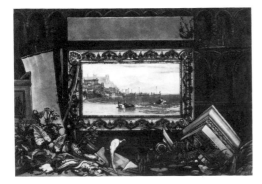

balances the division into light and dark and organizes the constituent elements in a
carefully calculated rhythm, something that may be seen for example from the
change of direction of the various ships' masts. We will come back to this manner
again at a later point.

Turner nonetheless endeavoured, especially in his seascapes, to achieve the form
with which he could most convincingly recall historical events and thereby create an
eye-witness impression. This was something for which the British public was espe-
cially eager – after all, the British fleet under Admiral Nelson spent two long years
continuously cruising up and down along the French coast, so as to prevent Napo-
leon's ships from leaving the harbour of Toulon. The Battle of Trafalgar (1805) had
a very far-reaching impact, deeply affecting the way that people lived in Britain at
the time.

Turner put all his ambition to the task of setting up a monument worthy of this
historic event. He drew the "Victory", on which Nelson had met his death, at an-
chor in Sheerness. He studied details, weapons, uniforms; he questioned eye-wit-
nesses. He carried out more advance work for the large-scale painting *The Battle of
Trafalgar* – including two large sketches in oils – than for almost any other picture;
however, it was precisely this documentary perfectionism, his wish to match the
painters of historical scenes, that placed him in an almost impossible situation artisti-
cally. The painting, which had been commissioned by King George IV, did not
meet with the expected praise.

However, the fundamental problem of representing movement in general in
pictorial form posed considerably greater difficulties for Turner than the attempt to
render an eye-witness impression. This conflict is clearly revealed in the criticism ut-
tered in connection with *Calais Pier* that the water appeared as if of stone, like the
veins on a marble slab.[19] A contradiction exists from the very start between the static
nature of the picture and the attempted portrayal of movement. This contradiction
becomes particularly evident in the context of a turbulent wave: however clearly its
"re-presentation" may depict it rising upwards or plunging down, what one sees in
the picture is merely "presented" in a particular position and possesses no movement
of its own. It is impossible to observe the temporal process of movement; it must be
inferred. We are touching here on one of the boundaries between the appearance of
art and the reality of nature, such as seem all too much a matter-of-course. Yet it is
precisely this matter-of-course element that Turner avoids in his later paintings by
changing the picture itself into the place where reality is experienced. This will be
discussed in greater detail at a later point.

In contrast, Turner would appear to have taken a different course with his pasto-
ral scenes. Although the depiction and perspective structure of such a painting as
Pope's Villa at Twickenham gives one a detailed impression of how the place looks, it
is not the aim of the picture to recall the scene as observed by the eye-witness.
Rather, it appears lost in the timelessness of the idyll. People are seen absorbed in
serene actions; the calm surface of the water reflects the villa, lying peacefully in the
sunlight; cows and sheep rest placidly. The English landscape metamorphoses into an
arcadian realm, taking on elements of fantasy, as in the painting *Crossing the Brook*
(p. 17), where the view opens out behind the soft silhouettes of trees to reveal an ap-
parently infinite and undisturbed nature. However, it is only to the slightest extent
that this "idyllic" impression is awakened through lyrical motifs of this type. A fine
golden colour covers the entire picture. Hard contrasts have been avoided. Dark
areas in the foreground or centre serve to create a kind of frame within the picture
for the background, itself kept mainly light, shimmering indistinctly, seeming to
draw one's gaze. It is solely through its scenic tranquillity and sense of having broken
free from the compulsion of realistic documentation that the motif contributes to an

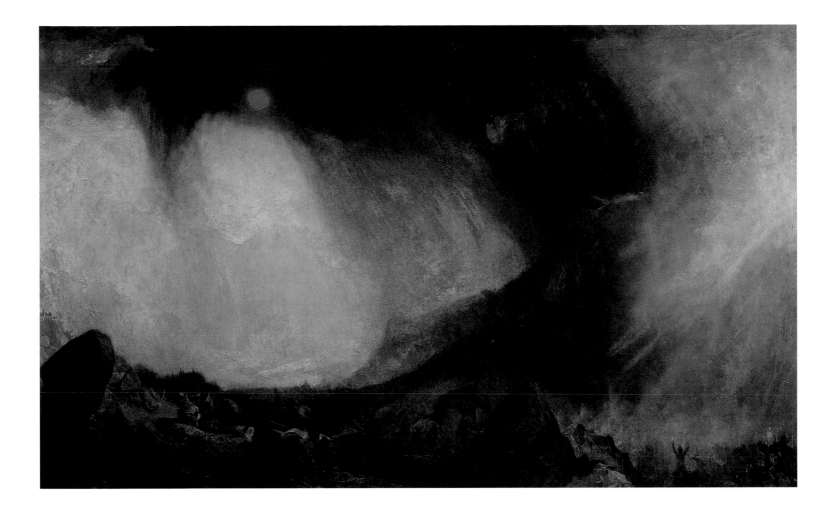

easing of the conflict between actual events and their pictorial manifestation. The events depicted seem wholly transformed into the coherent harmony of the pictorial form. The outward appearance of this harmony might suggest a relapse into the late Baroque manner, for it succeeds here only at the expense of a direct experience of reality. We will see how Turner's later pictures achieve their coherent harmony without such a loss of reality.

It is inevitable that Turner's mythical landscapes from this period suffer from this loss. However much he may attempt a realistic portrayal of the figures of *Apollo and Python* (p. 20, top), the horrific quality of the scene can only seem plausible if that which is implausible is simultaneously accepted as plausible. Such scenes aim at the unity of drama and depiction, accepting the potential danger that the high pathos inherent in the scene might appear hollow.

Here too, however, the path that Turner later adopted is characteristic. Towards the end of the 1820s, he took up the legend of Regulus in a painting of the same name (p. 54). The Romans had cut off this man's eyelids in punishment for his refusal to conduct peace negotiations with them as messenger of the defeated Carthaginians. As in others of his Lorrain paintings (p. 22), Turner depicts the scene in a harbour setting looking towards the sinking sun. However, the light of this scene is heightened by an unprecedented increasing of the yellow centre of brightness and an excessive reflecting of light, until it reaches such an intensity as if it wished to blind even the observer standing before the picture. And yet this impression is at the same time part of the subject: the observer can experience *through* the painting what is befalling the hero *in* it. The levels of reality appear to have merged with each other. A principle is heralded: What the scene conveys is experienced through what is directly observable.

Snow Storm: Hannibal and his army crossing the Alps, 1812
Oil on canvas, 146 x 237.5 cm
London, The Tate Gallery

"Craft, treachery and fraud – Salassian force,
Hung on the fainting rear! then Plunder seiz'd
The victor and the captive, – Saguntum's spoil,
Alike became their prey; still the chief advanc'd,
Look'd on the sun with hope; – low, broad, and wan;
While the fierce archer of the downward year
Stains Italy's blanch'd barrier with storms.
In vain each pass, ensanguin'd deep with dead,
Or rocky fragments, wide destruction roll'd.
Still on Campania's fertile plains – he thought,
But the loud breeze sob'd, 'Capua's joys beware!'" (Fallacies of Hope)

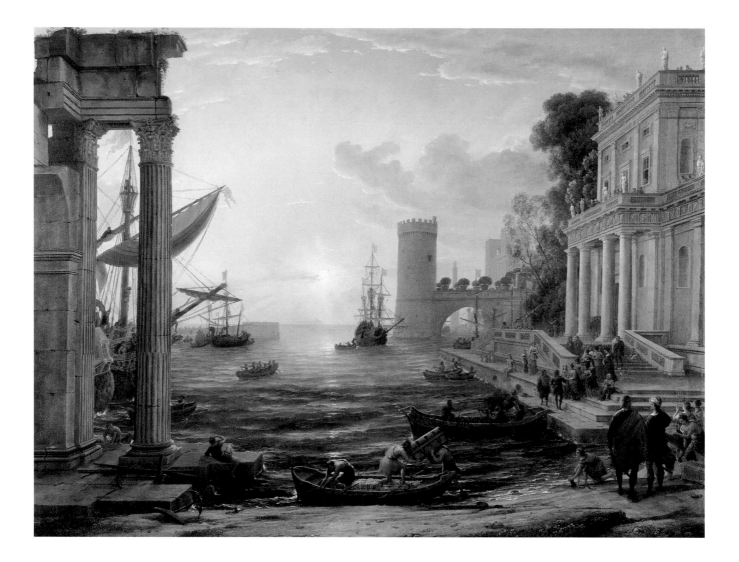

Claude Lorrain
Seaport with the Embarkation of the Queen of Sheba, 1648
Oil on canvas, 148.6 x 193.7 cm
London, The National Gallery

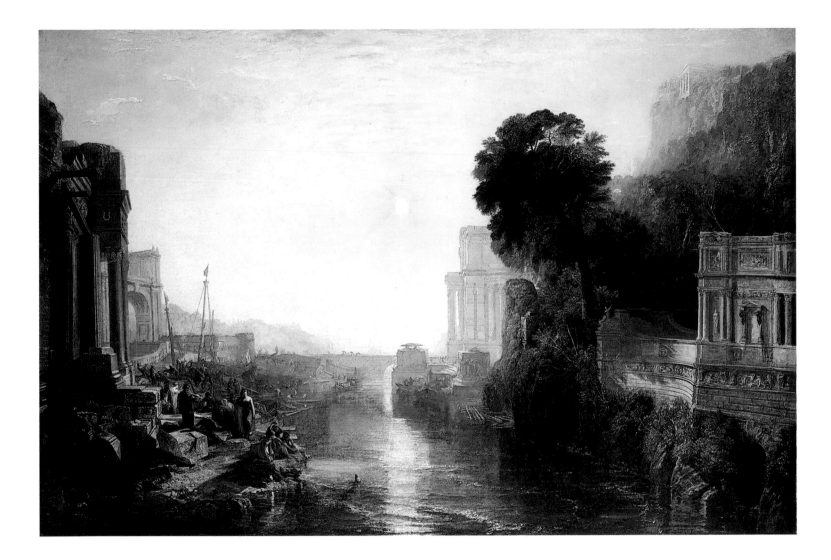

Dido building Carthage; or the Rise of the Carthaginian Empire, 1815
Oil on canvas, 155.5 x 232 cm
London, The National Gallery

Fishermen at Sea (The Cholmeley Sea Piece), 1796
Oil on canvas, 91.5 x 122.4 cm
London, The Tate Gallery

The Fifth Plague of Egypt (p. 18) finally displays the required heroic landscape. Storms and hail, rending clouds, sharp flashes of light, trees crashing down, victims' bodies and perished animals tell of the violence and fierceness of the general destruction. Here, too, the pictorial form can speak to us directly via the abrupt change from the dynamic transitions in the clouds to the geometrically clear structures of the pyramids, via the stark contrasts of light and dark, and so on. However, the effect of the often observed problem as to how incident is to be reconciled with aesthetic quality – a problem faced by Romanticism in general – is even more far-reaching here. While it is true that we encounter unmastered nature, the well-shaped catastrophe means that this occurs within the mastered unity of the comprehensible picture. There is a limit to the terror – although Turner has not recognized this limit.

The manner in which *The Fall of an Avalanche in the Grisons* (p. 15) is represented is far more radical. The masses of snow have loosened lumps of rock; one of them is being hurled through the air, while the largest, rearing up in a bizarre fashion together with the trees growing on it, is in the process of rolling over a hut, which is collapsing under it like matchwood. The radical quality of the portrayal lies not only in the absence of mythical fiction, resulting in the representation – at least thematically – of a blind natural event, as opposed to the mere illustration of such an occurrence as found in de Loutherbourg, for example. Turner also omits any figures, unlike de Loutherbourg, where they point with the utmost urgency to the terrible nature of the event and thereby turn the observer into a protected spectator. Tur-

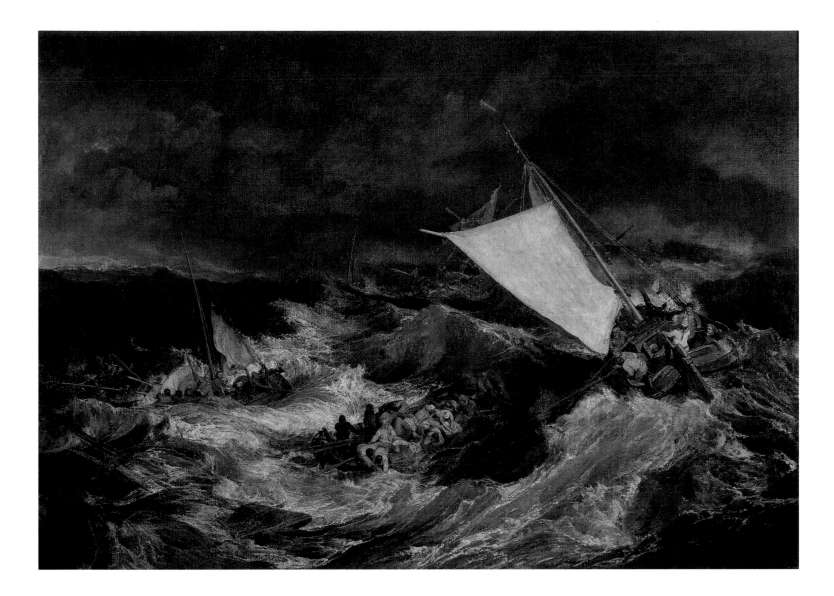

ner's observer, in contrast, is directly exposed to the event; the protective foreground is absent. The fact that what is depicted is not in fact possible in no way reduces the effect. It is clear neither whither the avalanche is moving nor whence it has come. All that is shown is that it *is* falling, and this only by such extreme means as the portrayal of a rock in free fall. It should be emphasized once again that the fall of the avalanche cannot be grasped until the observer comprehends the respective positions of the rocks as moving within the reality of the natural process, in contrast to their actual immobility within the picture. Within the temporal process of observation, the impression created by the block of stone depicted in free fall, and also by the block crushing the hut, is anything but one of movement – indeed, they seem fixed, rigid. The conflict appears insoluble.

The Shipwreck, 1805
Oil on canvas, 170.5 x 241.5 cm
London, The Tate Gallery

ILLUSTRATION PAGES 26/27:
*Calais Pier, with French Poissards preparing for Sea:
an English packet arriving,* 1803
Oil on canvas, 172 x 240 cm
London, The National Gallery

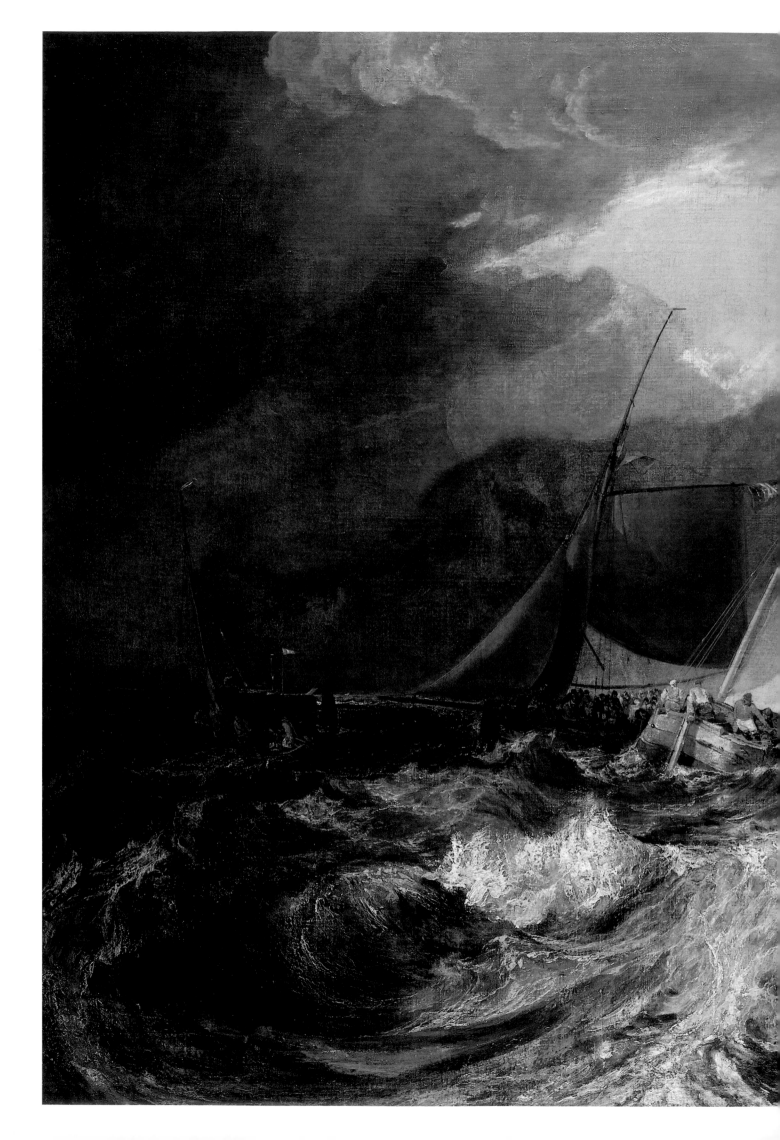

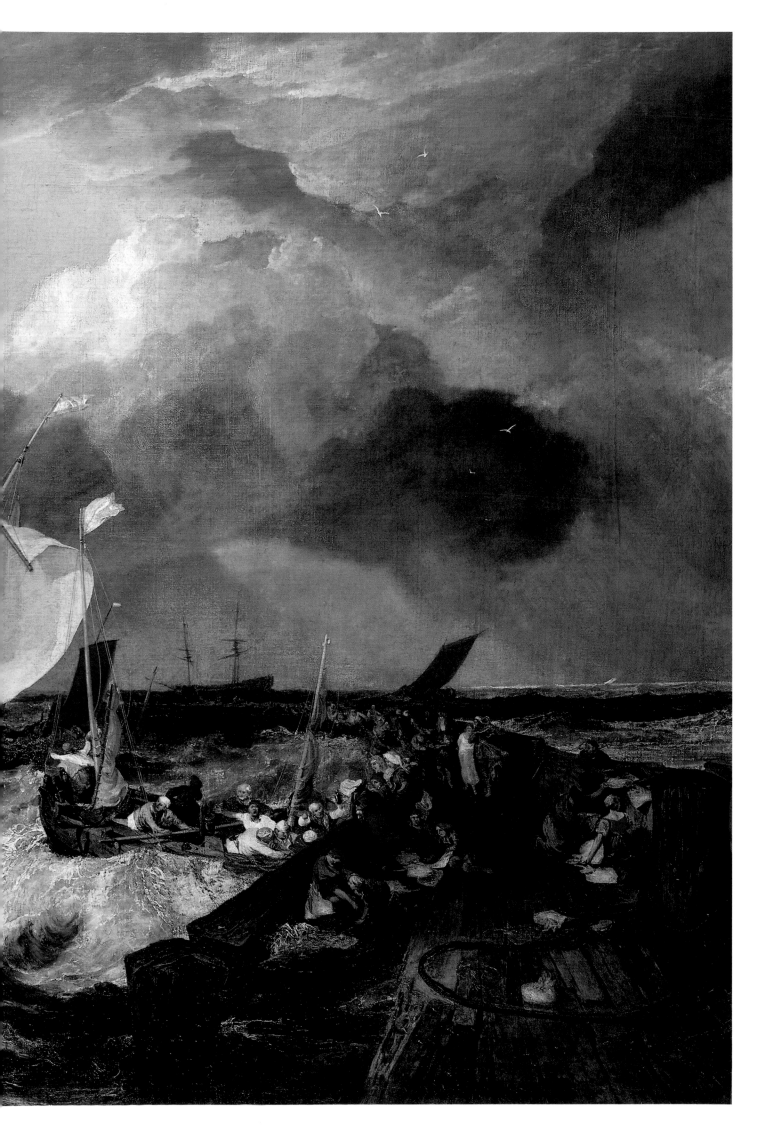

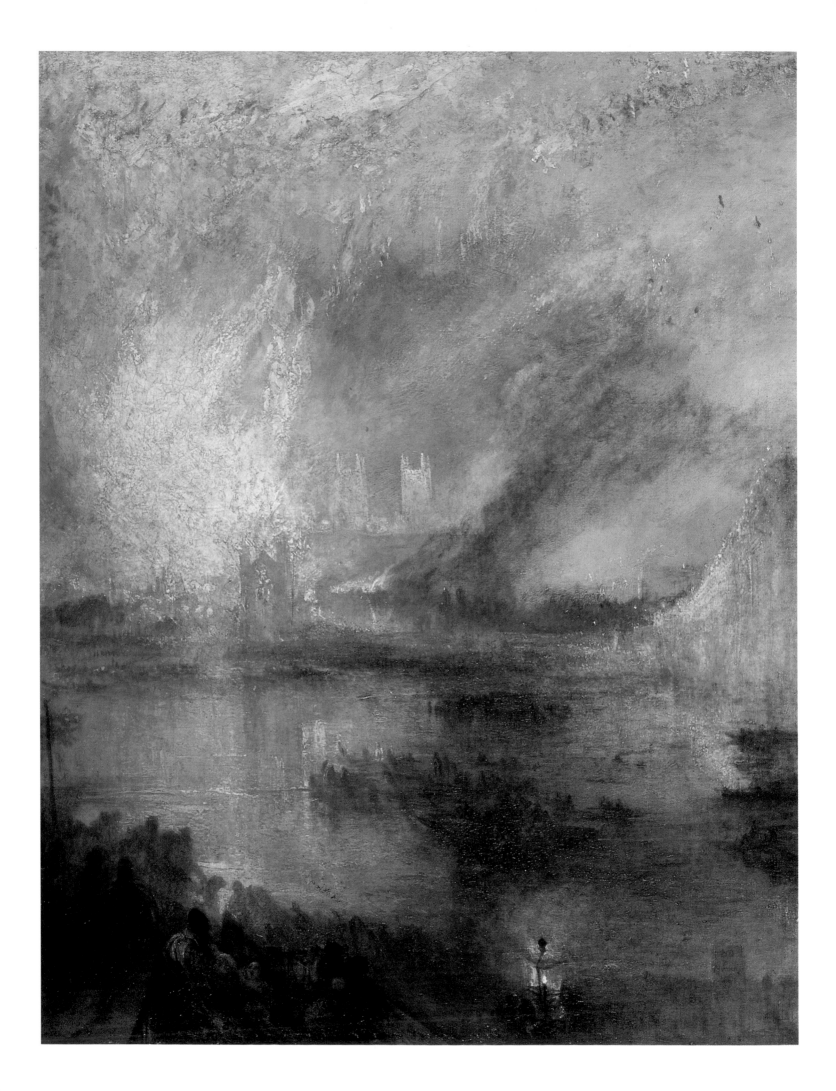

Completed structure becomes open form

How is a young artist to develop when he has already attained the utmost perfection in his profession during his early years, surpassing everything in his first creative period that his time could expect of him?

When Turner opened the first gallery of his own, in 1804, he was already a well-known and sought-after artist, one who had achieved recognition not only through his landscape drawings but also, more recently, with his oil paintings. Yet his drawings from this time show that he was already beginning to experiment with new forms of depiction, although greater evidence of this is to be found in his later output than in his work from this period. We are concerned here with experiments undertaken by the artist to further his own development; they were not originally intended for a wider public. However, his artistic attitude towards them was to change completely – in a manner typical of Turner – with the passing years.

Even today, the evaluation of the well-nigh incomprehensible abundance contained in the sketches remains incomplete. On looking through the collection stored in the Tate Gallery, the observer will find the effect of the fascination exerted by work after work anything but wearisome. The majority of the drawings are to be found in the sketchbooks which Turner never failed to take along with him on his travels. The diversity of the broad spectrum represented by the drawings displayed therein is in itself quite astounding, ranging from highly accurate and detailed works to rough light-and-dark drafts dashed off with indescribable spontaneity. Moreover, Turner by no means restricted himself when sketching to pencil or ink, but also used chalks, tobacco juice and – increasingly – watercolour and opaque paints. Nor was it rare for him to work with coloured paper, grey, brown or blue.

Turner's early work was concerned first of all with sketches in the classical sense – that is, with outlines, with preliminary works, with the collection of material, intended for a more thorough and complete treatment at a later date. He received a considerable number of commissions to prepare object drawings for engravings, which were then published in books and collector's albums. It is hardly surprising, therefore, that the idea of starting a collection of various motifs occurred to him. Furthermore, the production of preliminary works for engravings helped Turner develop his sketching ability. Such preliminary works were to occupy him again and again until he reached a considerable age; they also helped him earn his living.

If one leaves aside the very first attempts, it is remarkable with what meticulousness the seventeen-year-old proceeded. The previously mentioned *Cathedral Church at Lincoln* reveals the architecture involved in the strict framework of parallel lines and vanishing points to be precisely mapped out in its proportions, despite its great complexity. In contrast, the drawing *Rome from the Vatican* (p. 30, bottom), executed during the artist's first stay in Rome and serving as preparation for the aforementioned Raphael subject (p. 31), is dominated by a clear interest in building up the pic-

St. Erasmus in Bishop Islip's Chapels, 1796
Pencil and watercolour, 54.6 x 39.8 cm
London, The British Museum

Detail from: *The Burning of the Houses of Lords and Commons, 16th of October, 1834,* c. 1835
(cf. illus. p. 42)

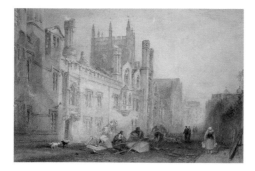

Merton College, Oxford, c. 1830
Watercolour with scraping-out,
29.4 x 43.2 cm
London, The Tate Gallery

ture's structure from the details of the town view to create a graphic context, one in which every stroke simultaneously represents the outline of an object. The contrast between this drawing and a free sketch for a classical landscape done fourteen years earlier (p. 32, bottom) could hardly be greater. In the latter, sensitive, tentative, freely flowing lines merely hint faintly at the figures and objects, but do not determine them.

Two different subjects for this work are written on the paper, namely "Homer" and "Attalus"; it follows that Turner began the drawing without first making a final decision regarding his subject. Indeed, he did not take preconceived ideas as his starting-point, but often let himself be led by the drawing itself as it developed. The *Sketch for a Sea Piece* (p. 33) also demonstrates how the character of the scene can be given expression even at this stage through the draughtsman's touch. Energetic strokes indicate turbulent water, towering clouds, ships' hulls and masts. Here and there dark hatching has been added, as if with rapid movements, lending the whole surface an element of intense drama despite the absence within the picture of any detail. The tendency is towards seeing the scene as a whole. Where the sketchbooks do occasionally reveal details, these are completely isolated – the basalt formations of Fingal's Cave, for example, or individual heads, trees, and fish.

The period of walking tours and travel, but also of keeping a diary and corresponding with friends, had begun. Turner's sketchbooks, which accompanied him on his travels, were more than mere collections of material. He used them to record the adventures which befell him on his journeys, when a coach broke down, for instance, or when the travellers were caught in the rain. His drawings became increasingly personal in nature, as the sketchbook became his diary. Sketching was also a way by means of which the artist, lacking a way with words, could inwardly come to terms with his experiences – indeed, reports state that he drew where others would write. The open pages of the *Rivers Meuse and Moselle Sketchbook* (p. 32, top) demonstrate the energy and intensity with which he recorded his observations. A double side reveals a dozen views at once, one next to the other, occasionally not even separated from its neighbours, as if they had been rapidly sketched on the page from the passing boat. Each view shows only a fragment; what is absent in one view is shown in the next. It is only when one sees the views in sequence that one experiences the infinite entirety of the world. Drawing is an integral part of the journey's procedure,

Rome from the Vatican, 1819
Pencil, pen and brown ink with body colours
on a grey ground, 23.3 x 37.1 cm
London, The Tate Gallery

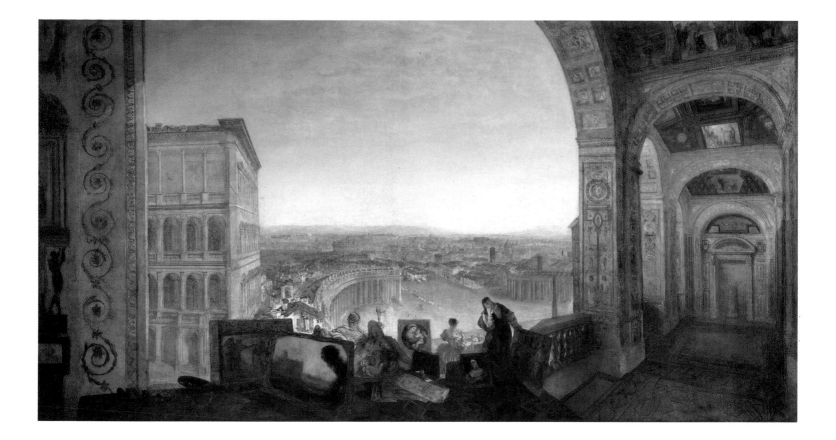

is part of the process of recollection. It is as if Turner's gift of imitation had enabled him to allow the drawing hand to directly experience the formative characteristics of the landscape. It was through the process of drawing that he really saw something. The numerous reports of his often looking at a natural scene for lengthy periods, apparently inactive, do not contradict this, since the speed with which he would then dash off his drawing would be all the greater. In Turner's hands, the sketch changed into a free medium of its own, by means of which the artist too could gain access to the course of events. His sketches often reflect a sidelong glance at human scenes or individual gestures, as in *The Bivalve Courtship* (p. 49). Turner would appear to have first discovered the charm present in merely hinting at something, in presenting it only fragmentarily, within the context of freedom in his own sketching.

However, it was not only through sketching that Turner found his style. At the same time, the use of watercolours was becoming ever more important for him. Towards the end of the 18th century, the aquarelle technique was considered a common process for colouring drawings. Even Turner's earliest watercolours are fascinating in their gentle, precise colouring. The nuances are applied extremely economically and used skilfully to portray convincing situations involving light and shade, vividly illustrating the volume of the forms, and particularly that of the buildings depicted. He was already making use of the transparent quality of watercolour paints in a very discriminating manner when depicting situations involving delicate shades of light in broad landscape panoramas and in interiors (p. 29). Instead of drawing first and then applying the paint, he switched to sketching out a coloured ground for the picture with sweeping movements using a brush with a wet-into-wet technique, thereafter putting in the drawing and any further details.

Turner refined his work with extensive layers of multi- or single-coloured washes to such a degree that effects resulted such as had hitherto been encountered only in oil painting. The artistic refinement of his watercolour technique is also visible in *Dolbadern Castle* (p. 11), where the light blue of the picture's ground turns

Rome from the Vatican. Raffaelle, accompanied by La Fornarina, preparing his Pictures for the Decoration of the Loggia, 1820
Oil on canvas, 177 x 335.5 cm
London, The Tate Gallery

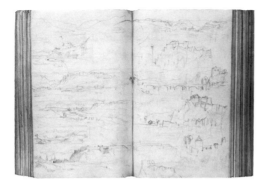

the cool atmosphere of a mountainous landscape when the morning sun breaks through the clouds into the dominant sentiment conveyed by the picture as a whole. It should be noted that the treatment given the blue colour conforms in every respect with that traditionally laid down. Turner allowed himself to be led by the rules of aerial perspective, as he was later to promulgate them in his lectures. Accordingly, the background blue reveals the spatial breadth. He successfully uses soft, fluffy brushstrokes not only to "re-produce" the individual elements in the landscape but also to depict in a comprehensible manner the haze in the humid air, the mist, the veils of fog, the clouds. Yet even these early pictures occasionally give rise to the vivid impression that the situation portrayed in the picture could change, that the mist could rise, the clouds move on.

The clouds' shadows seem to be moving on in *Llanberis* (p. 13), too. However, the freedom found here in the texture of colour, criticized by some as rendering the outlines unclear, may be considered first of all as a logical perfection of the transitory atmosphere's representation, the most exact observation possible of that displayed by nature. The watercolours from Turner's first journey to Switzerland similarly reveal how systematically the clarity of the pictures' grounds is distinguished, how vaguenesses in the background are only apparently so, are actually the result of exact observation. The watercolour of the Arveron Glacier (p. 14) testifies to the artist's precise observation of coloration. The bluish white of the glacier in the centre of the picture stands out against the white of the distant snow-covered peak, tinged with yellow, and the reflections of water from the river in the valley below. The atmospheric feeling becomes tangible – although this simultaneously affects the picture's explicitness. In this connection, a criticism voiced in the context of Turner's landscapes, that the artist was more interested in what lay between the firm objects than in the objects themselves, is particularly significant. However, the almost passionate perfectionism to be found in such works – which, after all, were intended to serve merely as models for the engraver, and were thus no works of art in the true sense of the word, even though Turner was indeed to pass them on to a patron later – led the artist to the boundaries of art, as he must have been aware, and as is even more readily apparent in his oil painting.

Sketch for a Sea Piece, c. 1816–18
Pencil, 11.1 x 18.5 cm
London, The Tate Gallery

We possess no evidence such as would indicate either an inner struggle with form, or crises or moments in which he fundamentally questioned his artistic abilities. As he developed further, however, it became necessary for him to overcome that which had brought him recognition up to now – indeed, that which he himself had promulgated in his professorial role, supporting the teachings recognized by the Academy. Early indications that Turner was gradually beginning to leave the safe path of pictorial tradition and realistic painting are visible in the sketches from his Scottish journey in the summer of 1817, and especially in the watercolours from his first journey to Italy. They signify a small revolution, albeit one that took place quietly. The bold attempts contained in his watercolour sketches and studies were revealed to his circle of friends alone. It is also remarkable that he never sought to promulgate this quite individual style of painting.

As a consequence of his increasing preoccupation with this style, Turner ultimately abandoned his teaching activities. The impression emerges that he never openly acknowledged – even to himself – the revolutionary element in his work. However, the new direction which this change brought with it was not the result of the expert's resignation to his own perfection; rather, it was stimulated by the completely new impressions stemming from his first encounter with Venice.

The Como and Venice sketchbook contains one of the so-called "Colour Beginnings" (p. 37). It is very similar to the ground for a watercolour from the same book, *Looking east from the Giudecca: Sunrise* (p. 34). Both have a simple structure of broad bands of colour laid horizontally on top of each other. It would be possible to imagine a further application of paint and gentle outlines to the coloured ground of the first work. After all, the arrangement of colours cannot be seen as neutral: a horizon is already becoming apparent, and the light blue leads one to expect a town or a promontory – as in *Looking east from the Giudecca: Sunrise* - which could stretch horizontally into the distance. The lower, brownish band also performs a spatial function, creating a foreground. The denser patches of what is nearer to steel-blue at the upper-left edge of the picture have the greatest representational purpose; indeed, it is possible – even in their present form – to see them as clouds.

It may be observed from the more elaborate *Looking east from the Giudecca: Sunrise* just how economical a depiction can be and yet still convey the impression of a complete landscape structure. A very few clearly recognizable structural shapes suf-

"We once ran along the coast to Brough or Bur Island, in Bibury Bay. . . . The sea had that dirty puddled appearance which often precedes a hard gale. . . . The artist enjoyed the scene. He sat in the stern sheets intently watching the sea, and not at all affected by the motion. Two of our number were sick. . . . In this way we made Bur Island. . . . At last we got round under the lee of the island, and contrived to get on shore. All this time Turner was silent, watching the tumultuous scene . . . absorbed in contemplation, not uttering a syllable. While the shell-fish were preparing, Turner, with a pencil, clambered nearly to the summit of the island, and seemed writing rather than drawing. How he succeeded, owing to the violence of the wind, I do not know. He, probably, observed something in the sea aspect which he had not before noted."
CYRUS REDDING

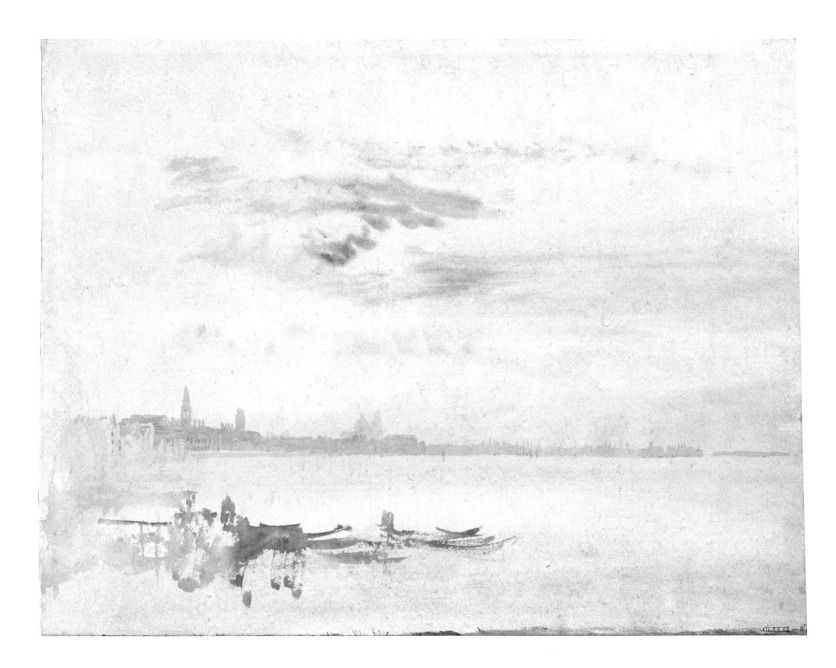

Looking east from the Giudecca: Sunrise, 1819
Watercolour, 22.4 x 28.6 cm
London, The British Museum

fice to give the other pointed and block-like brushmarks in the blue centre-sil-houette the semblance of distant spires and buildings, while a somewhat clearer gon-dola-like form suffices to give the other, freely and rapidly executed brown strokes the semblance of boats lying in the foreground of the picture. However, the work's great spatial effect depends to only a very small extent on the portrayed differences in size. The buildings of the town would not conjure up such a sense of distance, were they not completely absorbed by the effect on the observer of the blue colour. The spatial conception, on the one hand, based upon the perceived differences in size re-sulting from perspective, and the impression created by the colour, on the other, each achieve the same effect; in so doing, they also complement each other. Despite the openness and lightness of the brushwork, the spatial organization employed here constitutes an explicit, firm structure.

The simple *Colour Beginning* (p. 37) also possesses a powerful spatial effect. In this case, however, it is caused by colour alone, and it is impossible to ascertain the spatial relationships. The longer one looks at the painting as a whole, the more the number of possible interpretations which occur to one. Here we will mention only two. One of them sees the lower brown band as an expanse of sand where the obser-ver is to be found and which becomes a flat area of beach at low tide. Behind this the

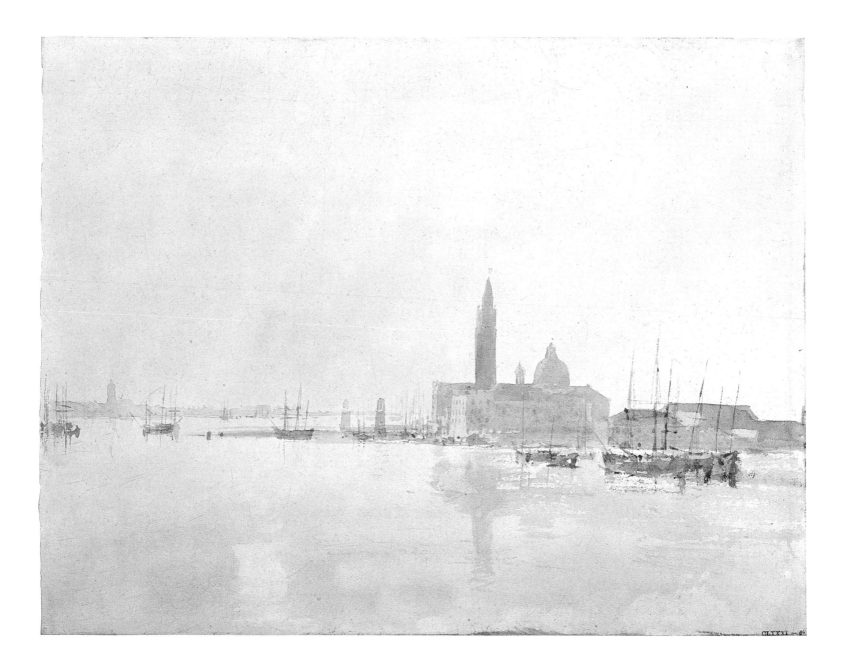

S. Giorgio Maggiore: Early Morning, 1819
Watercolour, 22.4 x 28.7 cm
London, The Tate Gallery

distant, open sea emerges against the brighter sky. In the other case, the observer is standing upon a hill, looking over a mist-filled valley at a chain of mountains in the far distance. An equal amount can be said for and against each version. There is no *one* conclusive interpretation; rather, the painting is open to a variety of interpretations. Furthermore, it should be noted that this open colour structure is not only ambiguous but also seems to change appearance according to one's interpretation. The process of change brought about by the possible aspects gives the picture an unexpected sense of life.

We can be sure that Turner did not regard this arrangement of colour as complete. However, many reasons may be taken into consideration as to why he did not continue work on this painting. Perhaps it was a failure in the eyes of the artist; perhaps the tone, the mood or the proportions were inappropriate, or the structure, in the form already on the paper, too extreme; perhaps it was simply put on one side at some point, and there was no suitable opportunity to continue with it at a later stage. The fact remains that there would be more and more colour studies of this kind in the years to come, and that they would be kept just as carefully – or carelessly – as the others.

The structure of colour described here can ultimately be accounted for as a

stage within the process of calling into being a conception in pictorial form; however, some later works quite clearly do not aim at the portrayal of a particular view. One can observe the way in which the artist increasingly allowed himself to be led not by observed natural objects alone but more and more by the effect of each transparent layer of colour, or by the flow of the wet pigment – something which he could of course control but which would never conform completely to a prior plan – together with the manner in which it dried on the paper. It is possible, but by no means essential, to see *The Sun Setting among Dark Clouds* (p. 38) – one of the many sunset studies from the 1820s onwards – as referring to a particular scene; this is the case with *Merton College, Oxford* (p. 30, top), a work adjudged "completed" by the yardstick of contemporary criteria. This latter once again displays both Turner's sensitivity with regard to the coloration of a scene determined beforehand through the drawing and, at the same time, his ability to use colour to lend the whole a general atmosphere; in *The Sun Setting among Dark Clouds*, on the other hand, the priorities of the means available to the artist seem turned inside out. The sun's fiery red orb and the red gathering of clouds in the upper-left corner contrast with a lower black-and-green and dark green-and-blue zone extending horizontally over the entire expanse of the picture. One's first impression may well be that this dark zone has been entirely painted in one colour; the closer one examines the picture, however, the easier it is to distinguish the colours.

A dark zone stands out against a somewhat brighter area underneath, one interspersed in the centre with a few traces of red. This second area may be taken to be the water's surface, reflecting here and there the red of the sun. The dark area above the water's surface may represent horizontal clouds and their shadows, or a cloud-covered strip of land above the water; however that may be, we can say with greater certainty that the area becomes ever more transparent upon closer observation, dividing into a horizon and a field of clouds surrounding the sun. One's gaze is led in this manner ever further into the distance, involving a total renunciation of any form of linear-perspective construction. It is also apparent that the red glow around the sun – like the yellow one above it – is caused by a previously applied colour ground onto which the dark colour was then laid in such a manner that this ground could still shimmer through or present a contrasting brightness to the applied dark area. The effect produced by such a shining through of the ground thus adds to the striking impression of depth, the former corresponding to the process of the portrayed situation as it occurs in nature.

Merton College, Oxford (p. 30, top) similarly reveals a ground which, having been previously applied, has nevertheless been painted over and is, as such, of transitory nature. However, the contours of the depicted subject mean that the scene here is refocussed on *one* particular aspect of place and action, whereas it is by no means the case that the elements described in *The Sun Setting. . .* can be imagined only thus and in no other way. As in the previously considered *Colour Beginning* (p. 37), the arrangement of colour bands follows no fixed interpretation. Each new possible interpretation allows the picture to appear in a different manner; the effect is one of movement, as if the clouds were actually in motion, observed forming and breaking up, as if the evening colours playing in the clouds were on the point of changing.

The motif of a changing atmosphere, noted previously in the early Scottish watercolours, is encountered once again – this time in a more intensive form – in aquarelles such as *The Sun Setting. . ..* In contrast to the early watercolours, however, there can be no conflict between the impression of motion and the static nature of things in the picture – although the pictorial depiction in *The Sun Setting. . .* is much more detailed than that seen in the 1819 *Colour Beginning*. The impression of what is depicted does not dissolve in the free play of possible interpretations, as would be

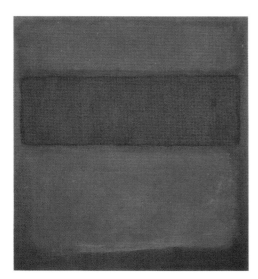

Mark Rothko
Untitled, 1963
Oil on canvas, 175.2 x 162.5 cm
Washington, Mark Rothko Estate

Colour Beginning, 1819
Watercolour, 22.5 x 28.6 cm
London, The Tate Gallery

The Sun Setting among Dark Clouds, c. 1826
Watercolour, 27.5 x 46.8 cm
London, The Tate Gallery

necessary if mountains had to dissolve in order to appear in motion, for instance; rather, it only constitutes itself in the form of the event of the setting sun. The principle emerges once again that everything which is rendered comprehensible by the scene may be experienced directly via the picture. The more the respective motif can be expressed in such a picture based purely upon colour, however, the greater the extent to which Turner himself must have consciously seen such a picture-form as possessing value in its own right. His experiments in this direction were to go further.

In *Ship on Fire (?)* (p. 75), a large black area of colour and another of a sketchy vermilion-red have been placed on what was originally a more or less buff-coloured sheet, the two areas of colour thereafter being extremely heavily washed, so that almost the whole right-hand side of the picture, starting from the centre, is covered with a second layer of wash in which black and red flow together. Hard outlines remain towards the left where the brush has been applied, and can be interpreted as the hull of a ship, while the liquid marks are dispelled like smoke and fire. The great economy of means can be seen especially in the drying marks and the strokes which have been wiped away from within the wet centre with an almost dry brush, these two elements leading to a reinterpretation of the brightness of the blank picture ground as the reflected light in the foreground of leaping waves.

One can no longer see these techniques as deriving merely from the necessity of perfectly describing the object. The observer is presented with structures which seem to conjure up a more general character through their weave of colour and dynamic form, that of a sunset or a fire on the high seas. They may be considered original studies, or inventions. Via the picture, an effect, a dynamic form, can become a direct experience for the observer, thereby opening his eyes to processes in nature which would otherwise have remained hidden to him. Turner had already pursued earlier methodical studies in order not only to reproduce the coloration of a group of

trees, for example, as it actually appears in reality, but also to allow the hues of green and the interplay of light and shade in the trees to emerge from the interaction of the primary colours blue and yellow. Now, in the 1830s, appeared constellations of colour, the shades of which are so very different from those expected by the observer. They nevertheless continue to be regarded even today as *preparatory* studies, and are thus rated as steps along the way to depiction.[20] Among these is the *Study of Buildings above a Lake or River* (p. 41), done around 1834.

The small format is dominated by powerful colour structures and the rough outlines of buildings. A prominent violet deepens between a powerful yellow on the left and a brilliant red on the right; however, it appears almost surrounded by violet washes. The red seems to extend towards the right, while the yellow is blocked to the lower left by an area of blue with no firm outline. Yellow and blue are intermingled here, but not in such a way as to produce green. The other intense areas of colour likewise fade towards the lower part of the picture to a paler shade. It would of course be possible to describe the picture in another manner, to speak of buildings, of water and the reflections therein. However, it would be all too easy thus to lose sight of the fact that the denseness and massiveness of the structure are not founded upon the conception of buildings but become directly effective as a quality of this packed colour composition; only from there do they have an effect on those object

Staffa, Fingal's Cave, 1832
Oil on canvas, 90.9 x 121.4 cm
New Haven, Yale Center for British Art, Paul Mellon Collection

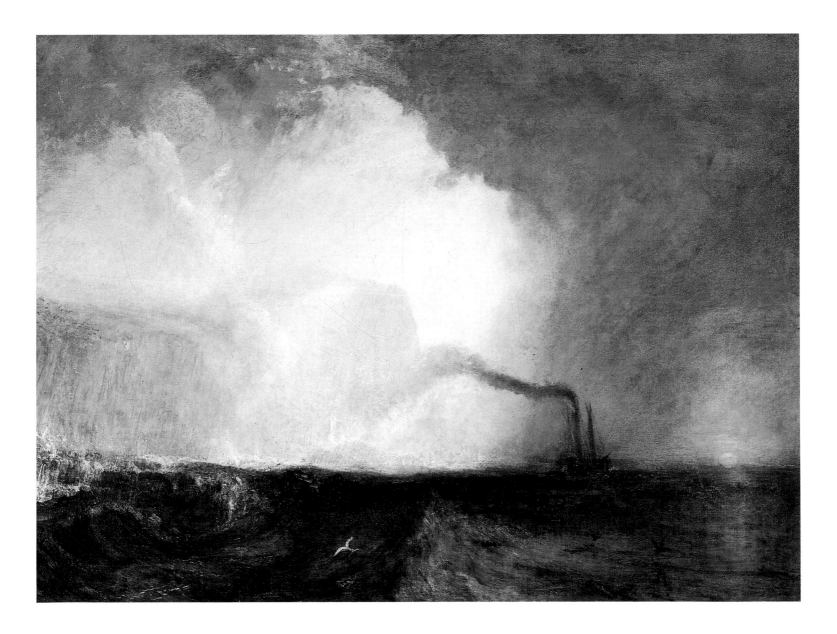

associations that are possible. The colours that light up against the grey paper bring their own lighting effect with them. One need no longer imagine that a sun – wherever it might be located – is the cause of their brightness. Colour becomes the protagonist; the conceptions of the objects have merely subordinate roles.

The same may be said of the late sunset study from around 1840 (p. 45). The observer is participating in a process of pure colour, in the process which takes place when the sun sinks and the colours in the atmosphere stage their greatest display, spread out over the entire sky, suffusing the clouds with light and then fading away. In participating in this process, the observer is experiencing nature in the making, is participating in the nature of nature – via the picture.

If one follows Turner's watercolours into their ultimate phase, it is possible to trace in them the attempt now to link the general laws of the natural processes with the individual quality of a particular place and a particular time. The effect of *The Blue Rigi*, for example, from the series of late Swiss watercolours, is such as if the almost 70-year-old artist had wanted to take up his early pictorial forms again, at least to the extent that it is possible once more to read the detailed birds and boats as conventional foreground figures, even if they demonstrate an absence of firm integration into the representational context of a clearly defined foreground. The water-surface motif permits the artist to let this indistinctness pass unnoticed. The individual elements seem to float. The mountain develops out of the finest layers of blue, remaining as unreal as the veil of haze over the lake and the banks.

There are times when it almost appears that Turner was using his sketches to pursue other goals than those for his "official" oil paintings. In retrospect, however, the former do indeed point to the direction taken by his painting in general following his first journey to Italy in 1818, although even his earlier oil paintings display great leaps ahead.

An example of this may be seen in *Snow Storm: Hannibal and his army crossing the Alps* (p. 21). Exhibited in 1812, the painting aims at *one* strong overall effect. The view opens out over some scattered rocks down into the floor of a valley, from which steep mountain slopes rise up to the right and in the centre. Dense nimbus clouds, their snow slanting in streaks far down into the picture, darken the place and conceal the view of the peaks. The sun is breaking through in the background and on the right in the distance, causing the swirling snow to light up. Sombre and overcast, the sun's disc shows through under an almost dome-like bank of clouds. The Carthaginian train is sketchily indicated at lower right, on the far left and further into the background. In the immediate foreground, a male figure is warding off a warrior, who has raised his dagger against a woman lying collapsed as if already lifeless. Some figures are crouching or lying exhausted, while others are observing the army's procession from hiding. Some animals have perished. The details of the marching army remain unresolved; they are submerged in the happening of the snowstorm, which impinges upon everything.

The title itself emphasizes the fact that the central pictorial event is the snowstorm. However, the effect produced by this event is achieved in a very different way to that observed in *Calais Pier* (pp. 26/27), for example. In the earlier work, the problem lay in the contradiction between the turbulence of the scene and the static nature of the picture; here, in contrast, one notices that it is not only the drama of a stormy landscape that is portrayed, nor is it only the figures which are subordinated to the stormy weather event. It is only in the foreground that their forms stand out against the great structure of light and dark, one which dominates the entire painting.

The powerful general effect, the character of the unifying "panoramic view" over the whole scene, even from a short distance and through detailed study, is achieved because the picture's observable light-and-dark structure – however it may

Study of Buildings above a Lake or River, c. 1834
Body colours on grey paper, 13.9 x 19 cm
London, The Tate Gallery

be interpreted – not only presents us with turbulent clouds and abruptly changing patterns of light but also itself appears turbulent. The interplay of light and dark itself creates a dramatic effect. The dark areas at lower left combine with the zones in the right-hand third of the painting and the upper edge to form a huge, compact element, one dominating the entire area without exception. The broad, dark band begins to the left, swings up in the right-hand half and falls back on itself, there to unravel downwards, as it were.

Report has it that Turner received his inspiration for this painting while observing a thunderstorm; indeed, the work can still be seen as derived to a large degree from a realistic weather situation. However, the concretely visible structure, together with its inherent drama, has such a dominant effect upon the observer that it can be regarded as containing the essence of the action. And it is no longer necessary, as it is in the heroic mythological scenes, to transpose the motif to be depicted into an imaginary context in order that it may be brought into accord with its representational appearance. The colourful light-and-dark element itself begins to include that which only representative structures – the landscape and the figures – communicate. Nevertheless, the principle discussed here still has not yet been completely fulfilled. Certain figures in the foreground may still be distinguished from the ephemeral overall formation in the service of the depiction of objects. *Snow Storm: Hannibal and his army crossing the Alps* is thus a picture that signifies radical change, one in which Turner

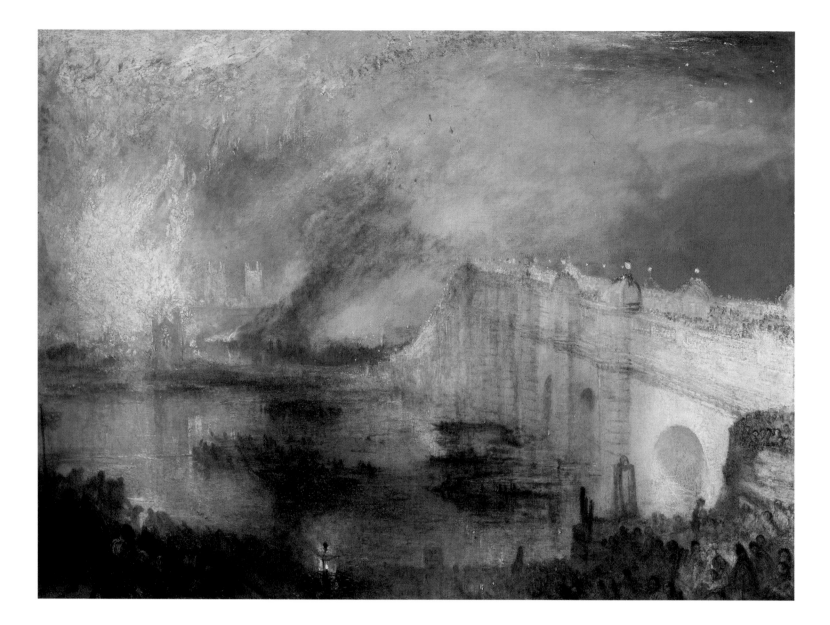

The Burning of the Houses of Lords and Commons,
16th October, 1834, 1835
Oil on canvas, 92 x 123 cm
Philadelphia, Philadelphia Museum of Art,
John H. McFadden Collection

first extensively activates the direct effect of the picture upon the individual in order
to influence the observer's comprehension of the event.

The drawing *Rome from the Vatican* (p. 30, bottom) is one of many examples
demonstrating Turner's mastery through a linear perspective even of complicated
views. It is all the more remarkable, therefore, that an examination of the large-scale
work for which this drawing served as a starting-point, namely *Rome from the Vatican.*
Raffaelle, accompanied by La Fornarina, preparing his Pictures for the Decoration of the Loggia
(p. 31), should give the feeling that parts of the foreground are constructed in so con-
fused a manner as to render the spatial organization unclear. The balustrade on
which the figure of Raphael is seated and where the female form is standing appears
to be twisted forwards; it is impossible to determine from the section in view how it
should continue to the left edge of the picture. In the immediate foreground are vari-
ous paintings, placed on a table draped with a red cloth. However, it is not at all
clear where and how this table is supposed to stand – nor, indeed, whether we are
dealing with a table at all, or rather with a step. The fact that the heads of the two
human figures are at different heights causes similar confusion: as they are rep-
resented here, the female form seems too small, as if out of place in the spatial system
surrounding her. Similarly, the transition from the left foreground to the buildings
behind gives the impression of a hiatus. The façade of the tall building on the left re-
veals clearly converging lines – yet these do not meet in a vanishing point.

The intention of pointing to such discrepancies is merely to draw attention to the fact that the perspective construction is not perfect, and that no systematic spatial conception can be built up. These more or less hidden divergences from the accepted constructional pattern were also criticized following the painting's exhibition in 1820. On the other hand, one can hardly suspect a possible constructional failure on the part of the expert in perspective, for Turner was to proceed in an even more extreme fashion in *The Burning of the Houses of Lords and Commons, 16th October, 1834* (p. 42).

The large bridge over the Thames constitutes the decisive spatial element here, taking up the entire right-hand half of the painting. In constructing it, Turner was no longer following the accepted rules. The right-hand section, in shimmering white, appears to be drawn in a parallel-perspective manner; in contrast, the perspective of the left-hand section, illuminated in glowing colours, is pushed beyond the realistic. It would of course be idle to attempt to measure this style of perspective in terms of the conventional rules, were its formal destruction not a characteristic indication of Turner's struggle to achieve a totally different form, to portray spatiality in pictorial form. It should be noted, both in this context and in connection with all further compositions by Turner, that the unity of what is depicted is in no way established any longer by means of a general spatial illusion applied systematically. However, this painting is also symptomatic in other respects, namely in its unusual composition and the spectacular circumstances of its origin.

Turner personally experienced the nocturnal catastrophe from a boat. The river, reflecting the blaze, is covered with boats. The Houses of Parliament are depicted above it, surrounded by bright flames which are shooting up into the sky. The glow of the fire is spreading out to the right over the bridge, whitish-grey clouds of smoke drifting away behind it. Only in the upper right-hand corner is a small area of blue night sky to be seen. Dense groups of people are thronging in the foreground, while others have gathered on the bridge. The scene creates an impression of the utmost urgency. The almost tangible heat of the fire on the left stands out most sharply against the pale stonework of the bridge. The flames flaring up and the black smoke alongside present a similar clear – and uneasy – contrast. The people in the crowd, pushing and shoving in different directions, also create an uneasy, restless impression. The boats, the forms of which are merely suggested, glide under the arches of the bridge, converge, and spread out again. The effect of the crowds' motion and the eruptive change in illumination is all the more dramatic when set against the immobility of the white bridge arches and the peaceful blue above. The bridge itself, however, appears to be floating and almost transparent – on the one hand, due to the absence of a firm spatial conception, as mentioned above; on the other, due to its gently blending into its surroundings underneath and towards the left, like the boats.

This principle holds true for all the other details. Only partially do they emerge from the ephemeral context dominating the picture as a whole – a few heads, a streetlamp, the bow of a boat. It is left open to the observer's imagination to isolate the objects further from the context, in the same way that it is left to him to allot them a specific place. From a representational point of view, the figures and objects in the depicted scene which can be at least partially identified lack any spatial point of reference. It becomes apparent that the gradual elimination of perspective construction mentioned earlier is no isolated incident but rather a special case of a general abolishing of the obligation for pictures of categories concerning spatial representation. One is made conscious of the whole depicted representationalism in such a manner that it is impossible for any established spatial conceptions to be built up. Furthermore, such a detachment of everything from its spatial definition proves here to be not only a problem of the world to be portrayed, to which these things

Colour Study: The Burning of the Houses of Parliament, 1834
Watercolour, 23.3 x 32.5 cm
London, The Tate Gallery

A Sunset, c. 1840
Watercolour, 24.8 x 37 cm
London, The Tate Gallery

belong. The principle of a closed composition is itself called into question. The unity of the picture, depicted in each and every part as ephemeral, can itself no longer be understood as possessing permanence.

This had already been announced in the backgrounds of earlier pictures. Here too, however, we are concerned only outwardly with the style in which a background is painted. Where such openness occurred in earlier works, caused by the objects in the picture, it was always integrated through other compositional elements, as in *Calais Pier* (pp. 26/27). The distribution of the ships, the ordering of the slanting masts, the grouping of the dark clouds to right and left, the bright accents in the clouds above, together with the light area in the water and the bright sail halfway between them, are parts of a perfect compositional structure, in which one part always corresponds to another.

In the case of *The Burning of the Houses of Lords and Commons, 16th October, 1834* (p. 42), corresponding counterparts can be found neither for the brilliant yellow area of the burning building, nor for the large white section of the bridge which fills the lower right-hand side. As an experiment, one can cover the relevant sides of the painting, the perpendicular of the central bridge pier – where the section lit in bright yellow borders on the pale one – being extended upwards and downwards to form the dividing line. If the right-hand side is covered up in this manner, then it is quite possible to see the left-hand side as a vertical-format composition quite complete in itself: the bright area of the fire would then contrast with the bright area at the bridge; the latter's outline, rising up to the right, could correspond to the lines of the clouds of smoke, likewise climbing up to the right; the dark cloud of smoke could be related to the dark mass of people at lower left; and so on. The other side, in contrast, if taken alone, is devoid of any such references. The large zone of the bridge appears somewhat isolated from the rest of the painting. The only possible measure by means of which one may join together the two sides of the painting, which a traditional viewpoint would regard as not corresponding to each other, would be the broad curve, open upwards, which ensues out of the line of the bank at the lower edge of the painting. Moreover, this curve may be continued to the left. It runs upwards along the left edge of the painting, leading halfway up to the yellow section of the bridge. Although this would also embrace the island-like dark areas of the boats on the water, even this offers no readily obvious way of including the upper zone of the painting.

These indications may suffice to make it clear that the picture's surface does not appear to be organized into a closed, observable system. Turner's previous work had already contained preparations for this, too. One might also be reminded in this context of the strange picture which he had designed for the curio collection of John Soane, the architect. It is full of individual fragments and views of buildings, covered by a great arch. However, the picture does not allow a conclusive spatial impression. It may have been sufficiently provocative that Turner in this manner prevented the consolidation of a realistic depiction in the picture. For this signified that he was beginning to resist the previously mentioned general tendency towards realistic representation, which was ushering in the era of realism and photography. The abolition of the pictorially clear coherence of compositional structures simultaneously signified a renunciation of every artistic tradition.

Snow Storm: Hannibal and his army crossing the Alps (p. 21) had already made it possible to a considerable extent for the observer to experience the pictorial structure as itself in motion. In the open structure of *The Burning of the Houses of Lords and Commons*, the movements – themselves motifs – as brought to the observer's awareness can no longer clash with their pictorial reference, for every pictorial reference would appear to have been done away with.

Claude Monet
Waterloo Bridge in Fog, 1899–1901
Waterloo Bridge, effet de brouillard
Oil on canvas, 65 x 100 cm
St. Petersburg, Ermitage

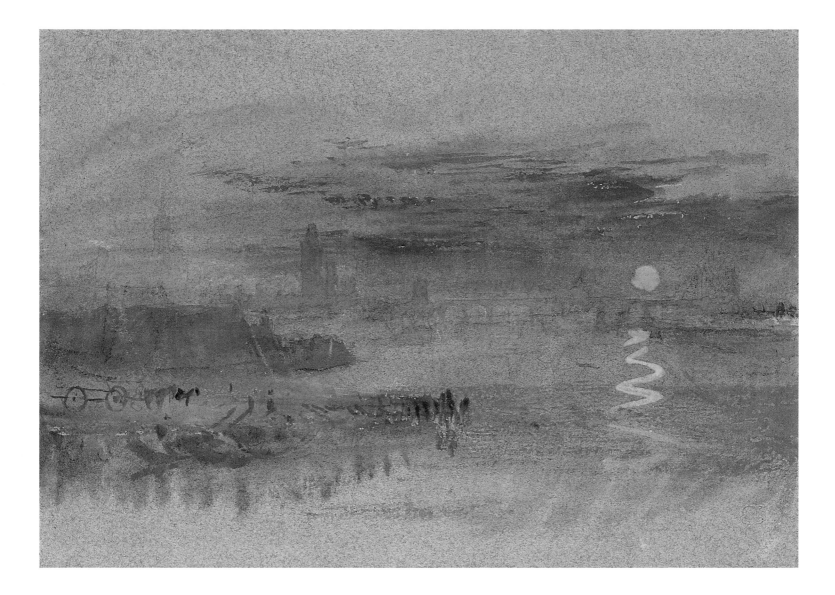

It emerges from the previous reflections, as a symbol of Turner's artistic development, that he progresses from a closed pictorial form to an open one, and not vice versa. It is in the nature of things that this openness subsequently cannot be described as a new system. It simply causes that which is to be observed as a pictorial experience to constitute itself anew each time. Before characterizing the quality of this new formal construction more closely, however, we must first take some further aspects into consideration.

A Town on a River at Sunset, c. 1833
Watercolour and body colours on blue paper,
13.4 x 18.9 cm
London, The Tate Gallery

The artist's world: mental conception and pictorial realization

In experiencing the effect of the world as portrayed in the picture, the observer is simultaneously experiencing the picture of that world as it may be found in the mind of the artist. As a rule, it is possible to learn more about an artist's conception of the world by taking the well-trodden path and, leaving the realm of art, examining utterances, circumstances, and the situation at the time in question. In the case of Turner, however, the observer constantly finds himself referred back to the artist's works themselves. The reason for this is inherent in the very individual observational nature of the artist's pictures.

The impression may arise that those things into which Turner sought to delve further were such as defied verbal expression, that the only way in which he could express – and perhaps also define for himself – his relationship to the world was via painting itself. With the exception of events involving the institution of the Academy, which meant so much to him, he withdrew increasingly from public life; in later years, he was to keep his address secret, sometimes giving himself out to be an Admiral Booth. He maintained contact neither with his two illegitimate daughters nor with their mother, Sarah Danby. Following the death of his father, his life took on an ever more eccentric character.

Only a few individuals were granted admittance to his private gallery, which fell into a state of increasing disrepair. He protected himself through increasingly peculiar behaviour. Those who did not know him took him to be mad. Others record his gift of making highly apt observations, his affection for children, his cryptic sense of humour. He was constantly the butt of mockery, although it was extremely seldom that this provoked any reaction from him. Even John Ruskin's enthusiastic apologia of his art elicited at best rare comments of a merely passing nature from the artist.

The manner in which an artist portrays people is always influenced to a considerable extent by his own attitude towards his fellow-humans – himself included. It is significant that – apart from early experiments (p. 9)[21] – Turner's work contains no self-portraits. The only exceptions are to be found in a few Petworth sketches; these will be examined in greater detail in the following pages. He would appear to have attached greater importance to the depiction of other people, particularly in the context of their relationship to the world around them.

This is already apparent in the first watercolours: the people are an integral part of the scene, representing what is happening in the place in question. Turner was concerned less with the individual than with the typical. Numerous pictures also express an uncomplicated pleasure in narration. Only seldom did he take a scene concerned solely with some happening or other, an event between people, as his main motif.

To such pictures may belong a work from the early 1830s, one which has sometimes been interpreted as a scene from the "Merchant of Venice".[22] We are con-

The Bivalve Courtship, 1831
Pencil, 8.5 x 11 cm
London, The Tate Gallery

ILLUSTRATION PAGE 48:
Music Party, Petworth, 1835
Oil on canvas, 121 x 90.5 cm
London, The Tate Gallery

Interior at Petworth, c. 1830
Watercolour and body colours
on blue paper, 13.9 x 19 cm
London, The Tate Gallery

nious entity. The room appears filled, and the observer has the impression not so much that he is gazing in from the outside but rather that he is being directly drawn into this atmosphere. It may be true that certain elements of the situation remain unclear; however, there is a complete absence of a feeling of artificial arrangement. Neither the imaginary room nor the picture assign the figures a clearly determinable position; accordingly, they not only create a relaxed impression but may even appear to be gently moving. One should notice Turner's success in depicting a scene involving people in a manner that brings it to life when it is to be seen within the context of a house's interior.

In including people in his landscapes, Turner was following a custom of his time. However, the role which he gave them was never as significant as that bestowed upon them by Caspar David Friedrich, for example (p. 76). In his paintings, Friedrich constantly presents the observer with people absorbed in the contemplation of nature: thus, the observer within the picture is doing the same as his counterpart standing before it. The latter considers the former as an integral part of the picture; he sees not only nature depicted but also the manner in which it is seen. However, Friedrich's pictures do not only present the man in the picture as quite clearly no part of nature at all but also see him as face to face with it. It follows that the majesty of nature can only be experienced indirectly, that it is always simultaneously the representation of an inner experience, a reflected view of the world, rather than the world itself. Turner, for his part, let the human forms merge increasingly into the formal context of his depiction of nature. If his later works portray people at all, then they are always in groups, encountered by the observer as if a part of nature. The *Festive Lagoon Scene, Venice?* (p. 55), for example, merely hints at forms – it is impossible to ascertain whether they are in boats or on a quay – together with their general movement, their reflections in the water, and their colourfulness; however, we are not brought face to face with any individualized figure such as would create a sense of distance. We have already noticed in our examination of *The Fall of an Avalanche in the Grisons* (p. 15) that Turner was quite capable of dispensing with the intermediary figures customary at the time. The figures become superfluous to the same degree that that which the observer is made aware of through the picture

can itself become the event. Turner does not present us with a vision of the world: rather, we form our own view in observing the picture.

Since 1798, artists exhibiting at the Academy had been permitted to include quotations of some length from texts or poems in the respective catalogue entry for their pictures. Few artists made such extensive use of this possibility as Turner. However, he soon took to composing the verses for his pictures himself. These initially had the character of a commentary, serving to place the depicted scene in the appropriate meaningful context. The first painting for which he wrote the lines himself was *Apollo and Python*; their dark and martial style is characteristic of Turner's verse in general. Following contemporary convention with regard to citation, Turner identifies the lines contained in the subtitle to *Snow Storm: Hannibal and his army. . .* and the majority of works thereafter as a quotation from a longer epic, "Fallacies of Hope"; however, this work was not found in his estate, and presumably consisted only of those passages found under his pictures. The overall tenor is that of the sceptic's pessimism: seeing through these vain 'fallacies of hope', he knows how every pursuit of higher things will end. The lines alone sufficed for an interpretation of *Snow Storm: Hannibal and his army. . .* as referring to Napoleon's disaster before Moscow. It was solely on the grounds of the accompanying text that *Slavers throwing overboard the Dead and Dying* (pp. 90/91) was seen as a condemnation of slavery;[23] the painting caused a considerable sensation. And yet these commentaries to the pictures also provide evidence of a biographical nature. The basic mood of resignation found in the "Fallacies" corresponds to Turner's retreat into himself and his painting. Furthermore – and however one might regard his poetic output – one cannot but be moved when one of the last sketches, *Lost to All Hope the Brig. . .* (p. 74), depicts a listing, half-sunken wreck, with the barely legible text: "Lost to all Hope she lies. . .".

However, an examination of Turner's later commentaries reveals that they

Ulysses deriding Polyphemus – Homer's Odyssey, 1829
Oil on canvas, 132.5 x 203 cm
London, The National Gallery

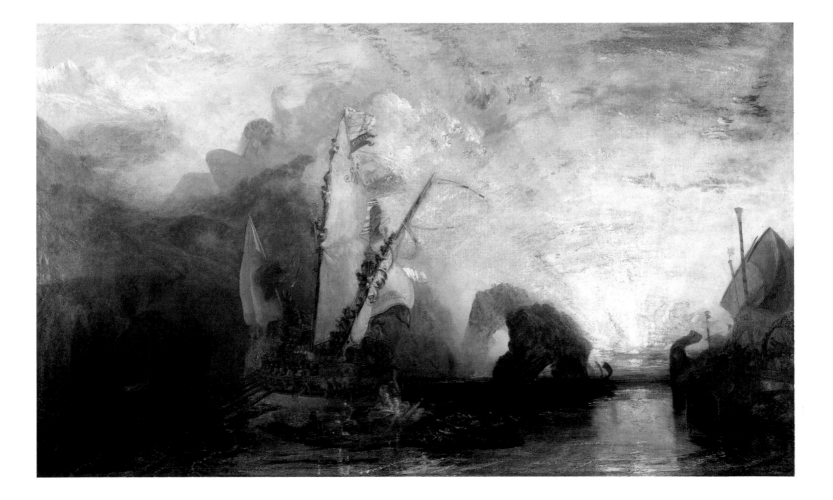

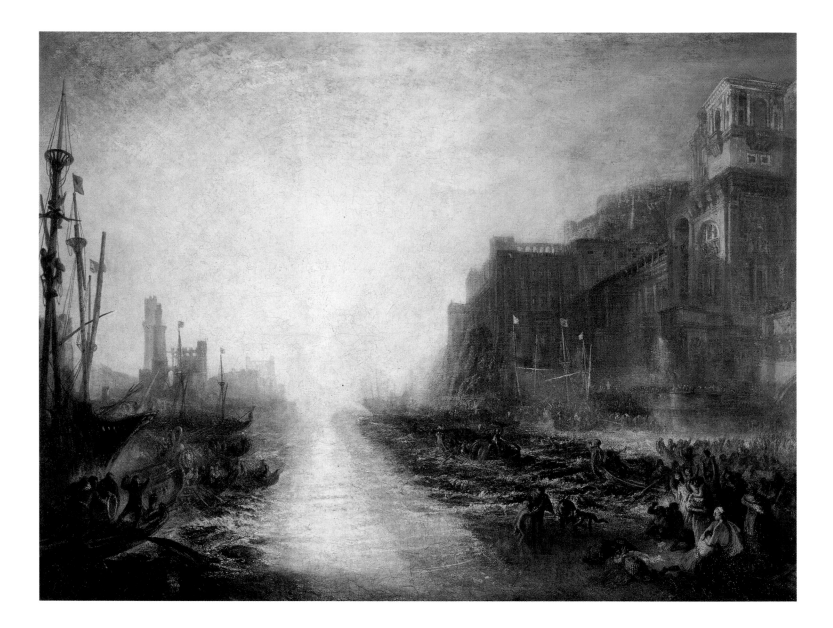

Regulus, 1828
Oil on canvas, 91 x 124 cm
London, The Tate Gallery

were to become as needy of interpretation as the pictures themselves. The lines that they contain often give one the impression of having come into being after their respective pictures, as if Turner were striving to express verbally what he was experiencing through painting. In some cases they render the meaning behind the picture even more mystifying. It seems not unfruitful to bear this possibility in mind when attempting to interpret the complex compositions *Shade and Darkness – the Evening of the Deluge* (p. 86) and *Light and Colour (Goethe's Theory) – the Morning after the Deluge – Moses writing the Book of Genesis* (p. 87).

Indeed, the lines accompanying these two paintings tell us scarcely more than can be deciphered from the paintings themselves. For example, the words "But disobedience slept", referring to *Shade and Darkness. . .*, could be seen as a reduction, in the sense that it was the people who did not follow the moon's warning of the coming suffering who slept; however, it remains quite unclear whether this statement is to be seen as applying to a scene that scarcely allows of any definite interpretation as it is, or to individual figures instead.

In the same way, the lines for *Light and Colour. . .* allow for a totally open association of ideas. Mention of the grounded Ark leads to a reference to "bubbles", which evaporate in the light and are as ephemeral in their "prismatic guise" as the mayfly. Are we concerned here with the small shapes surrounded by spheres which,

Festive Lagoon Scene, Venice?, c. 1845
Oil on canvas, 91 x 121 cm
London, The Tate Gallery

close together, fill up almost the entire lower half of the painting? In what respect do they have prismatic form or colour? Or are we dealing simply with an allusion to the rainbow, symbol of reconciliation, in which can be seen the prismatic colours?

Even the relationship between picture and text is revealed here to be an open one. Indeed, the unusual title, *Light and Colour (Goethe's Theory) – the Morning after the Deluge – Moses writing the Book of Genesis,* is more an indication of a belated search for words to describe something only emerging in the course of the painting process itself – in the face of a pictorial context such as eludes words. It would appear that Turner was not granted the gift of being able to create verbal structures in such a way that they corresponded to the dynamic forms contained in his pictures. It is precisely in their lack of success that Turner's efforts as a poet comment upon the painter's relationship with the world of his own pictures. Ultimately, they eluded even his own attempts to interpret them verbally. Even he, as their painter, could experience their message solely via the observation of the pictures themselves. At the same time, this touches upon two qualities which characterize the world as depicted in Turner's later pictures: the mythical element, and the riddle.

The fact that Turner introduced mythological motifs into his landscapes time and again would appear to contradict his striving after the observational element, since such motifs assume at least a corresponding prior knowledge if interpretation is

Detail from *Ulysses deriding Polyphemus –*
Homer's Odyssey, 1829
(cf. illus. p. 53)

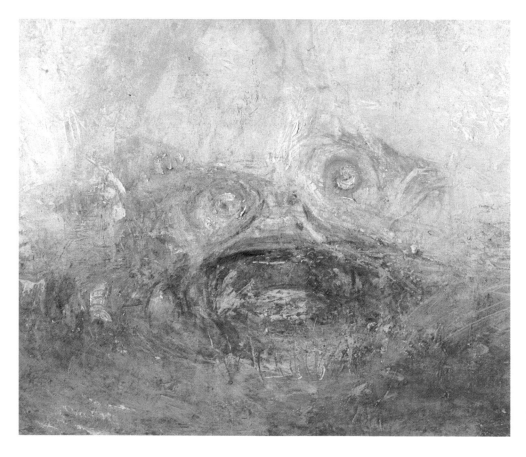

Detail from *Sunrise with Sea Monsters*, c. 1845
(cf. illus. p. 59, top)

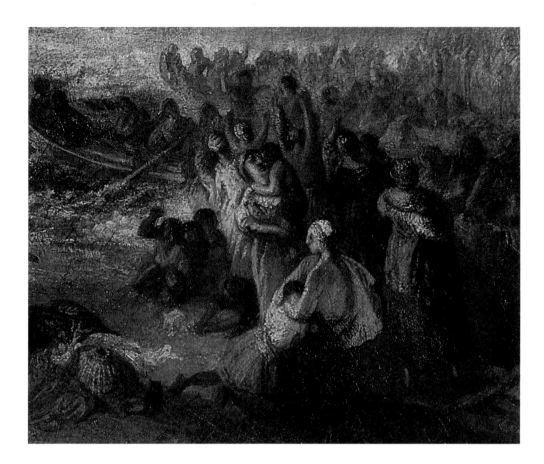

Detail from *Regulus*, 1828
(cf. illus. p. 54)

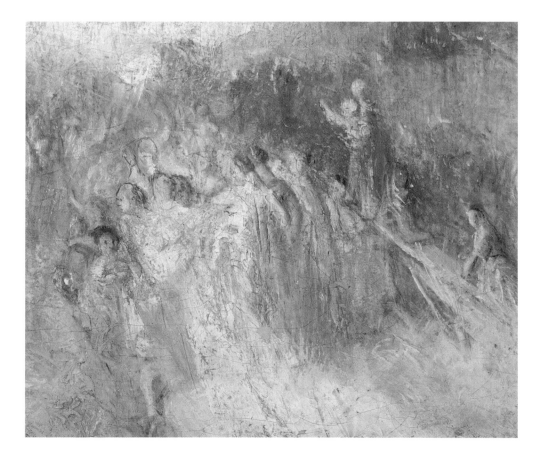

Detail from *Festive Lagoon Scene, Venice?*,
c. 1845
(cf. illus. p. 55)

to succeed. However, his pictures would suggest that the mythical element had a greater significance for the artist than simple convention or merely a pictorial rendition of generally known classical themes with no connection to the reality of the scene from nature which he was depicting. Furthermore, motifs from Arcadia were to bring an inner world to visible expression.

The Bay of Baiae, with Apollo and the Sybil (p. 19) portrays a particular landscape. At the same time, however, the landscape is considerably stylized. The chains of hills drawn up behind each other, for example, grow brighter until they merge with the central blue area of the sea, producing a rhythmic succession of light-and-dark values, which leads to the centre of the picture and can be seen as contributing to the impression of distance, peace and harmony. Nor are arcadian attributes lacking: ancient ruins, distant ships, the shepherd with his flock, figures from mythology in idealized human form.

These motifs also appear to be aimed at relieving the depicted scene of its reality to such an extent that it can be identified with the portrayed event. However, the endless distance, the peace, and the harmony are given a touch of familiarity from bygone eras through the inclusion of the ancient stones and the divine figures. Through these motifs, the peacefulness of the landscape is revealed as a transformation of human traces into nature, as memory in the form of nature. Nature appears as an inner world rendered visible. Through Turner's pictorial form, the representation of mythology is subjected to an interpretation, a deeper meaning: the depiction of divine forms is to serve as a means for rendering comprehensible in human form the forces inherent in the world. Yet this describes but the starting-point for the way in which Turner was later to use myth.

Indeed, a development is immediately apparent when we examine the portrayal of the Cyclops and the Nereids in the mythological painting *Ulysses deriding Polyphemus – Homer's Odyssey* (p. 53; p. 56, top). Polyphemus – at upper left – can hardly be distinguished from his surroundings, almost disappearing into it. One can test this by covering up his head, upon which his body can no longer be identified. In a manner comparable with that of Arcimbolo's picture puzzles, the giant's shoulder and hip become the rocky mountain-top behind the ship, while his beard and hand, the latter raised to throw a stone, vanish in the clouds. It is not until one sees the one-eyed face that the representation of the cliffs above the ship is reinterpreted as the threatening Cyclops.

Nereids and a number of mythical fish may be seen in front of the ship's bow. These figures, too, cannot be clearly distinguished from their background. The effect of their transparent forms is extremely artistic, as if they were woven from the foam, the sparkle and the reflections of the water's surface, half-figure, half-glittering wave-crest. The mythological creatures are formed from the interplay among the elements of shape and colour, from cliff formations, from clouds, from waves, and are thereby characterized as a force in nature. In this way, they become the representation of the power exerted by the elemental forces. They are given shape by the elements, in the same way that they give the elements shape.

This serves to alleviate the contradiction between the pictorial representation and the direct effect of nature; however, it is still present. Nonetheless, Turner's efforts to show more than merely the superficial side of the world would appear to have led him back again and again to mythical motifs as a means of thematic mediation between picture and nature. After all, the observer has a different relationship to mythology than to his sensory perception of nature. Mythology, too, has its reality, which is characterized by the fact that it is nothing other than a pictorial – narrational – representation of man's unconscious relationship to the powers of life, and consequently to the elemental powers within nature – "natura naturans".

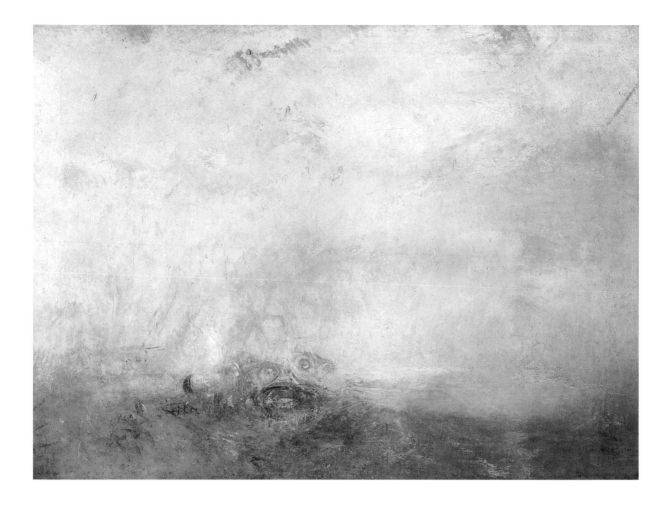

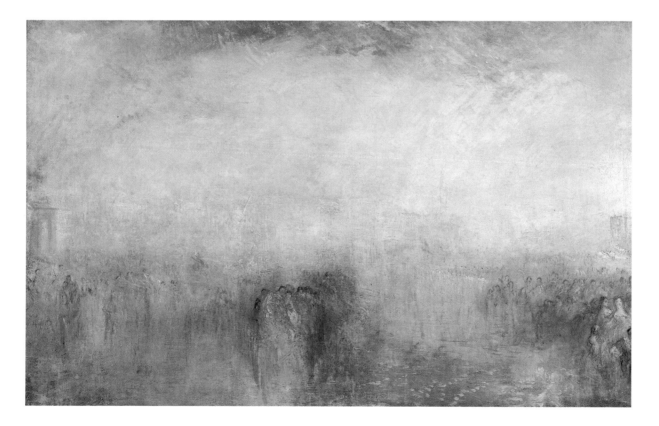

View of a cross-canal near the Arsenal, c. 1840
Water- and body colour over pencil, with dabs
of pen and ink on grey paper, 19.1 x 28 cm
London, The Tate Gallery

We have already touched upon the complex interaction of pictorial meaning
and observational perception in the case of the mythical scene *Regulus* (p. 54). That
which the hero undergoes as his "internal experience" starts to become the "external
experience" of the observer, inasmuch as he can experience himself the sense of
being blinded through his observation of the picture. This results all of a sudden in
the observer's sensory involvement in the subject-matter of the picture. The mythi-
cal dimension means that by actually looking at the picture himself, the observer is
investing the mythical event with present relevance.

It would nevertheless seem logical that Turner increasingly dispensed with
mythological motifs, restricting himself to the representation of landscapes alone in
the majority of his works. The reason for this, as will be seen, was the discovery that
his form of depiction was itself opening up a way which he had previously found
only thematically, that is, through the inclusion of mythological elements. An abun-
dance of sketches and oil paintings exists in which Turner concerns himself solely
with depicting the effects produced by the elements. An entire sketchbook was filled
with cloud studies. His later work reveals an unbelievable perception of the distinc-
tions in the interaction of wind and water. Nothing more than the natural process,
pure and simple, is depicted: compare *Breakers on a Windward Shore,* and the manner
in which wave pushes against wave, or the flying spray from the breaking crest is
whipped away by the wind, vanishing into the mist and clouds. However, it is im-
possible for the observer to remain uninvolved with the events in the picture. The
centre of one's field of vision is placed far down at the lower edge of the picture. As

a result, the impression is that the waves tower up ever higher, at the same time as they occupy almost the entire width of the painting. The observer's gaze finds nothing on which to focus, but is distracted by one area of brightness after another. The only relatively calm zone would appear to be the foreground of the picture, thanks to the expanse of water, seen as if from a distance, faintly reflecting the light, running off the beach. One's gaze can only linger there for a moment, before being drawn once again to the motion of the waves. The observer becomes a participant in the action.

The majority of Turner's work is devoted to the search for possible ways of depicting light in its elementary manifestation. No matter which picture has been examined so far, it has always revealed an attempt to depict light – or, to be more precise, to depict light as it appears in the atmosphere. Light can be viewed as an essential component if any objective form is to be rendered visible. However, Turner was to discover via his art what Goethe had worked out in the course of his scientific studies, summarizing the whole as a theory for the first time in his *Farbenlehre* ("Theory of Colours"), setting out the conditions that are necessary if light itself is to become visible to the eye. When drawing landscapes, Turner would occasionally depict the same place at different times of day and in different seasons; the innumerable sunrises and sunsets and all the studies of the colours of the atmosphere were focussed upon the natural element of light, which, itself invisible, can only manifest itself via something else, a cloudy medium or solid objects. The manner in which Turner depicts light can be alluded to here by means of only a few examples, connected in each case with a place which is characteristic for the artist's conception of light, namely Venice and Petworth.

The pictures from the artist's first visit to Venice which we have already considered (p. 34, 35, 37) demonstrate the considerable extent to which Turner went to create the world as he saw it through the effect and counter-effect of the various colours. Those works stemming from his second and third (1840) visits are devoted entirely to studies of light.

View of a cross-canal near the Arsenal (p. 60) shows a highly subtle interplay of light and shade, one in which light, its reflection, and the image thrown back by the water complement each other in a variety of ways – indeed, it is only through this mutual act that they become distinguishable at all. The most delicate pastel shades grow brighter or darker. Houses, bridges and boats seem to be woven from this interplay of colour. The façades in the centre and on the left, which have been brightened with white, present a contrast to the more intensely colourful red, blue and green areas on the right. In so doing, they create a structure consisting of two areas facing each other with a third in between; boats, the water, sunbeams and shadows can be seen moving in the latter. We should not regard the objects which become recognizable in this scenery, nor the space in which they are to be imagined, as having their own existence, defined in this way and in no other. The space in which the objects appear takes on substance through their manifestation. A system of perspective is unnecessary. The open pictorial structure described previously enables a depiction of that which is effective between the objects as something that is taking place – a fundamental quality with regard to light, since it is only when it is functioning actively that light manifests itself.

Something similar may be seen in the numerous nocturnal scenes, effects with light forming the constitutive elements of the depicted world. Thus in the watercolour *Moonlight* (p. 66), for example, it is possible to observe how the impression of depicted objects is created solely from the different colour compositions, but one of such a nature that it is valid – as may be seen here – for only a moment. The soft reflections in the water lead one's gaze upwards to the zone of the sky, to which they

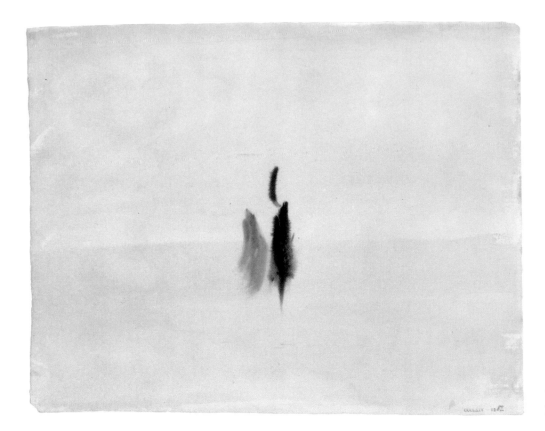

Boats at Sea, c. 1835–40
Watercolour, 22.2 x 27.9 cm
London, The Tate Gallery

relate. The only spot where a representational element would seem to take on solid form is the dark area in the centre of the picture, apparently floating there as if weightless. It is only when one views everything as a whole, including the blue zones above and below, that the thought occurs that we could be looking at a ship. The colours do not merge with that which they – barely – make graphically recognizable. The colour compositions remain visible, as if they had their own form, thereby producing a purely visible effect such as interacts in a specific manner with the other colour compositions, the counterpart for the realm of colour to the manner in which moonlight plays under boats in the water.

The series of final Venetian paintings (p. 55; 59, bottom; 63; 93) constitutes the culmination of effects produced by light in the atmosphere. Everything that can still be interpreted here as depictive is absorbed in a completely freely fluctuating coloration. It is left up to the observer to what extent he forms a conception of clearly delineated objects from the elements of colour, each of which can be isolated from the others only with difficulty. The weave of colours of itself causes an experience of dynamic brightness, without this being interpreted representationally. The atmospheric interplay of colours becomes visible in its pictorial counterpart. It is similarly impossible within the act of observation for the shades of colour, in part completely interwoven, together with their brightenings and darkenings, to appear as isolated values.

As in the *Colour Beginning* from 1819 (p. 37), so here too one's impression changes, as different qualities of colour and degrees of brightness become prominent or wane corresponding to the observer's point of view, glowing brightly or fading

Venetian Scene, c. 1840–45
Oil on canvas, 79.5 x 79 cm
London, The Tate Gallery

away. Thus, in the *Festive Lagoon Scene* (p. 55), the primary colours, yellow, red, and blue, are incorporated in a white background, which brightens these colours yet simultaneously links them all together. A first glance will suffice for the observer to describe the entire area of the sky as predominantly blue; however, a closer examination reveals that the sky contains a touch of red. Then again, it seems as if it is suffused with yellow, only to immediately appear predominantly bluish. In the same way, it is quite impossible to separate what one immediately perceives as red figurations in the area of the figures from those in yellow, the figurations accordingly appearing to be more red or more yellow in colour. Nothing can be clearly defined. The colour reference, the quality of the phenomenon, alters in accordance with the extent of attention of the observer. Not even the consciously undertaken attempt to hold on to one particular conception of the picture in one's imagination, to fix it somehow, is successful. The impressions are so fleeting that they disappear in the moment one points to the colours. As with the objects that are to be imagined, so with the colour: it is only in the process of its manifestation that one becomes aware of it – not only representationally as the colour of the atmosphere, but also as the colour used in the painting. And what has already been said here may suffice to justify the assertion that the direct effect of colour, as concretely visible in the picture, is experienced directly as the effect of light. Whenever light appears, then it is via colour. However, if colour itself can be understood as a manifested form, as seen in Turner's later Venetian pictures, then the pictures reveal the principle of light to be the principle of manifestation itself.

The more than one hundred Petworth sketches, dating from between 1830 and

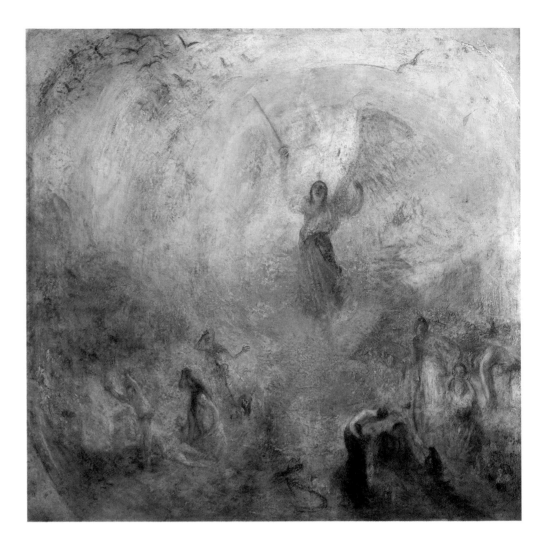

The Angel standing in the Sun, 1846
Oil on canvas, 78.5 x 78.5 cm
London, The Tate Gallery

1837, show predominantly interior views, similar to those offered by the rooms of the great house today: the library, which served Turner as a studio, the staircase, Lord Egremont's fine-art collection, the music room, the White and Gold Room, and so on. Here, too, Turner is most successful in portraying people in as relaxed and apt a manner as possible. The familiar conversation between the artist and a young man about a painting (p. 50) reveals a completely harmonious view of objects and figures, but also something more: an intimacy such as could hardly be expressed adequately in words. Furthermore, it is significant that it was in these surroundings that the only pictures portraying the artist himself at work were painted (p. 51).

We are concerned here with a quite unique kind of self-portrait, one lacking any form of self-representation. Landscapes have been described before in which the people were to be understood as an integral part of the events in the place concerned. In this case, the artist presents us with his place of work and, in so doing, portrays both himself and his work. The motif of the artist, whether working or musing over his painting, is almost a natural component of this place. And if he himself appears in the picture, as is here the case, then the picture reveals how the picture becomes the picture. Once again, we are presented with the union of observer and observed so characteristic of Turner's later work.

In this process, too, more is required of the immediate colour effects than the function of making objects comprehensible. They also appear here as objective manifestations, as should be readily apparent and require no further comment. The painting *Interior at Petworth* (p. 52) – probably the Old Library, with the artist standing and working in front of his easel, which is thrown into contre-jour shadow – reveals pre-

Detail from *The Angel standing in the Sun,* 1846
(cf. illus. p. 64)

dominant shades of blue and violet, with delicate nuances moving towards the yellow in a few places. Moreover, these colours can no longer be derived from a particular lighting situation; rather, they themselves create a particular mood. Such an experience, completely dependent upon the effect of the colour alone, is anything but usual for the 1830s. Goethe notes in his *Theory of Colours* that if one is to experience the full effect of an individual colour, then it is necessary to "completely surround the eye with one colour, for example by being in a room of one single colour, or looking through a coloured glass. In so doing, one identifies oneself with the colour; it brings eye and mind into a state of harmony with each other."[24] According to Goethe's description, blue, reddish–blue (lilac), and bluish–red "call up a restless, soft and yearning sensation."[25] "Rooms the walls of which are papered all in blue appear large, so to speak, but actually empty and cold."[26]

It only remains for the characterization of Turner's picture to take into consideration the colouring with a violet hue as a brightening element. Turner's picture, too, can be said to "bring eye and mind into a state of harmony with each other". Colour becomes a purely inner experience. Colour objectivizes the mood of the depicted room. One could say equally well that it subjectivizes itself to meet the mood of the person observing the colour in front of him, immersing himself through his observation in the colour. It is a matter here of a double process, one in which colour becomes the actual sphere of experience. The illusionistic "reproduction" of an interior scene is no longer significant. The quality of the experience resulting from the interior scene portrayed in the picture is revealed directly through the mood suggested to the senses by the effect of the colour, through the coloured nature of the picture.

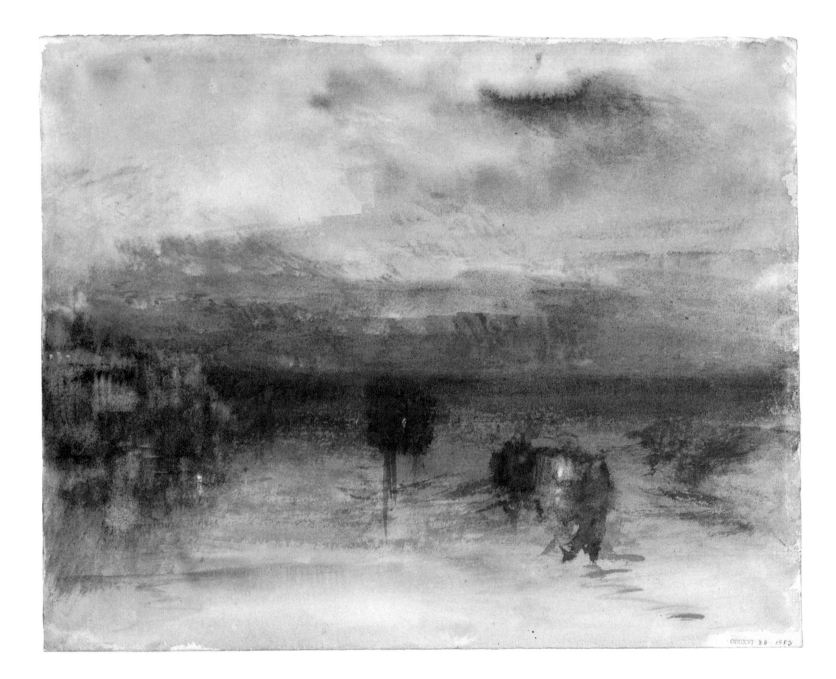

The open picture and its manifestation

The preceding remarks advanced the principle of the effect of colour alone. However, an understanding of the nature revealed by Turner's later pictures must take into consideration more than just this principle. The process of painting has its own decisive part to play.

Thomas Monro had encouraged the talented young artist to study the procedure adopted by Alexander Cozens. This consisted of laying down the characteristic arrangement of forms in a landscape picture by means of dots and broad lines – so-called "blots" – leaving all that remained to a later reworking, in the course of which all the details in the picture would be built up. Turner was often to follow this pattern in his drawings; indeed, a comparison may readily be made between it and the technique of his *Colour Beginning* pictures. It may also be the reason why he strongly disliked being observed while engaged in drawing or painting, for the element of chance in the creation of a picture, something not always available to the artist, must not be forgotten here. An anecdote has it that Turner, wishing to produce such a structure of blots, had small children pat the picture with their hands; another anecdote records the process by which the drawing of a warship was created from a crumpled and stained piece of paper.

If one traces the course of the artist's development, then it is in the free watercolour studies mentioned previously that the process of painting itself – and not only the natural scenery in question – is seen to become the actual source of inspiration. Turner received his observational impulse from that which his brush portrayed. He subordinated the painting process from the start neither to the structures which he had conceived in his mind, nor, however – as has been seen – solely to the abstract effects of the surface itself. The path that he took was so extraordinary on account of his ability, when observing a picture which he was painting, to take the result and mould it completely in the character of nature as he saw it. It would seem, therefore, that his initial genius in being able to adjust himself to the artistic character of another painter had now metamorphosed into the ability to directly accord with the effects of nature through the forms painted by his hand.

This can generally be said to be true of the late sketches. That which may be taken to be sky, horizon and water in the sketch *Moonlight* (p. 66) is in fact a free arrangement of colour, one which seems to develop out of the individual effects of the structure of colour; this latter does not conform to the constraints of realistic depiction, but could be congenially re-created and intensified in the picture only through the painting process.

It was in this process of intensification that Turner's great proficiency was gradually revealed. The characteristic qualities of his early works, an accuracy and precision combined with a refined coloration in recording the objects of his depiction, metamorphosed in the course of his development into a quite superior artistry with

S.W.Parrott
Turner on Varnishing Day, c. 1846
Oil on panel, 25 x 22.9 cm
Sheffield City Art Galleries, Ruskin Gallery

ILLUSTRATION PAGE 66:
Moonlight, c. 1840
Watercolour with dabs of body colour,
24.5 x 30.3 cm
London, The Tate Gallery

regard to the calculation of the effect produced by the interaction of colours and brushwork within a rapid process of painting. At first, Turner had strongly disliked being observed while working; now he went so far as to demonstrate his painting himself in public. During the final days before Academy exhibitions, the artists were permitted to apply the final coat of varnish to their paintings in order to make them accord better with their surroundings (p. 67). These varnishing days became social events among the Academy members, enabling as it did not only the exchange of professional views but also a continuation of the unavoidable argument with regard to the best positioning on the walls used for the exhibition, these – following the custom prevalent at that time – being covered with pictures from floor to ceiling. Turner saw such days as an opportunity not only for a final touching-up of his work, but also for considerable alterations; indeed, in his final years he would submit paintings not much more than the grounds of which had been completed, finishing them – or rather, only now actually painting them – in one session and in the course of a few hours on varnishing day.

It was this process in particular which earnt him admiration, if also considerable mockery. With hindsight, we can observe that Turner belongs to the first artists for whom the creation, the act of painting, began to play a role for the picture.

A pictorial form in which the sketch could no longer be differentiated from the completed painting was unable to fulfil the expectations of the early 1840s public. The painting *Snow Storm – Steam-Boat off a Harbour's Mouth making Signals in Shallow Water, and going by the Lead. The Author was in this Storm on the Night the Ariel left Harwich* (pp. 70/71) was disparaged as "a mass of soapsuds and whitewash".[27] This was the kind of criticism which animated the young Ruskin to defend Turner. The painting reveals the extent to which Turner sees the style of the brushwork itself as a contributory factor in the impact of the picture.

It is as though the entire surface had been worked through with alternating large masses of light and dark. Various shades of brown-black contrast with white and dirty white-grey. A floating blue appears only towards the middle of the picture, finding a form of reflection at upper left and lower right. Otherwise, the coloration

Page 9 from the *Ideas of Folkstone Sketchbook*, 1845
Watercolour, 23 x 32.4 cm
London, The Tate Gallery

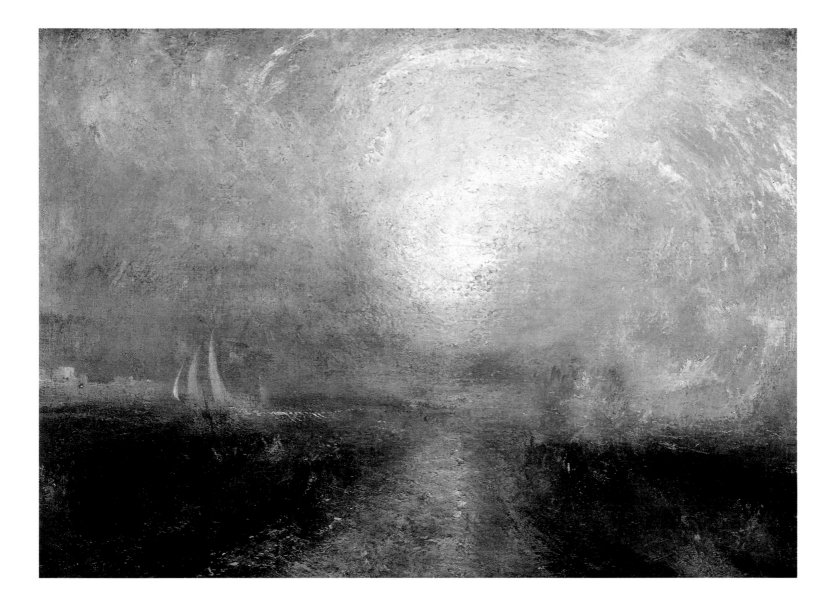

is completely suppressed, compared with the massive light-and-dark structure. The most pronounced contrast is to be seen half-way up on the right, towards the centre. Some bright brushstrokes parallel to each other form a small semicircle in the almost completely black area. These may be interpreted as the paddles of a paddle-steamer, while the black line rising diagonally to the right can be seen as the ship's mast, together with a fluttering pennant. Otherwise, the only indication that we might be looking at a boat is a completely vague, dark outline, continued downwards in a manner that could suggest a reflection in the water. The dark-brown area fanning out from the middle of the painting towards the upper edge and twisting like mist can be interpreted as smoke whirled away by the storm. Furthermore, the almost transparent formations below, through which the parallel dark brushstrokes seem to permeate, may be regarded as the crests of high waves seen from close up. The white area at centre constitutes the brightest element, almost dazzling through the contrast with the otherwise dark surface; it is surrounded by the aforementioned blue colour – a brief glimpse of sky through a gap torn in the clouds – and cut in two by the mast, apparently bent to the left by the force of the wind. We are confronted with a snow-storm, illuminated by the sun's rays as they break through for an instant. Nevertheless, the colours repeatedly emerge everywhere as areas of applied pigment, and the entire painting is covered with visibly left in brushstrokes, often running parallel to one another on areas of the surface, together with traces of the palette knife.

Yacht approaching the Coast, c. 1835–40
Oil on canvas, 102 x 142 cm
London, The Tate Gallery

ILLUSTRATION PAGES 70/71:
Snow Storm – Steam-Boat off a Harbour's Mouth making Signals in Shallow Water, and going by the Lead. The Author was in this Storm on the Night the Ariel left Harwich, 1842
Oil on canvas, 91.5 x 122 cm
London, The Tate Gallery

"I did not paint it to be understood, but I wished to show what such a scene was like; I got the sailors to lash me to the mast to observe it; I was lashed for four hours, and I did not expect to escape, but I felt bound to record it if I did."
J.M.W. TURNER

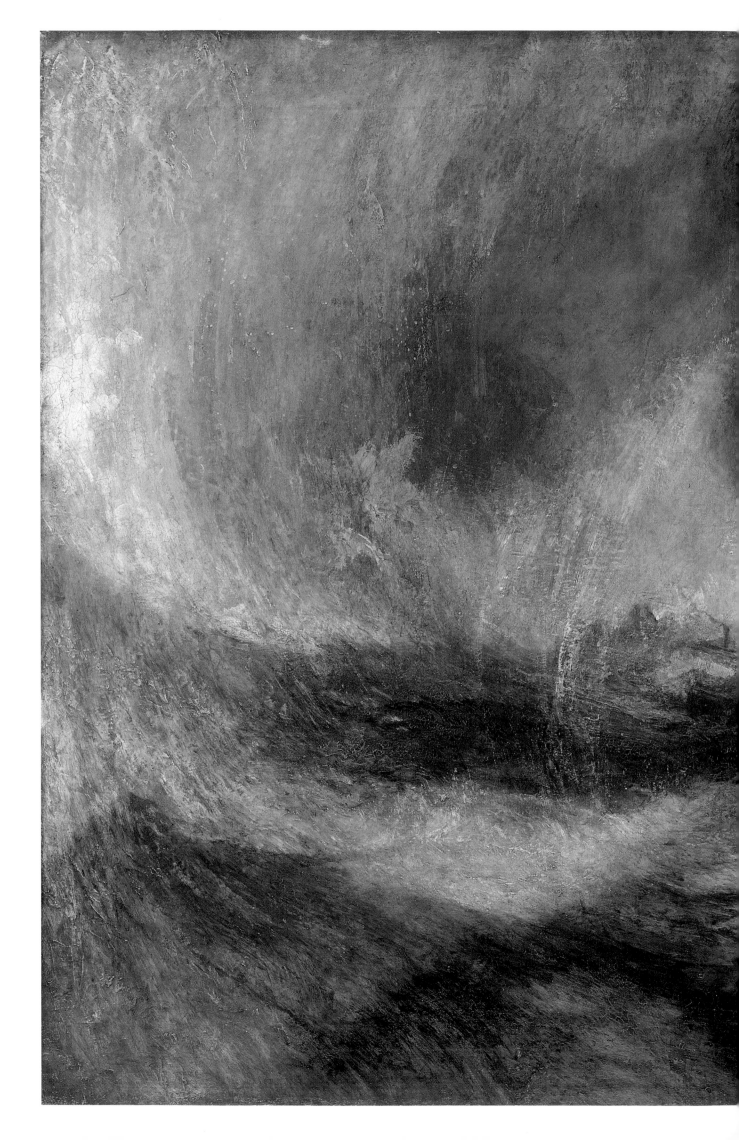

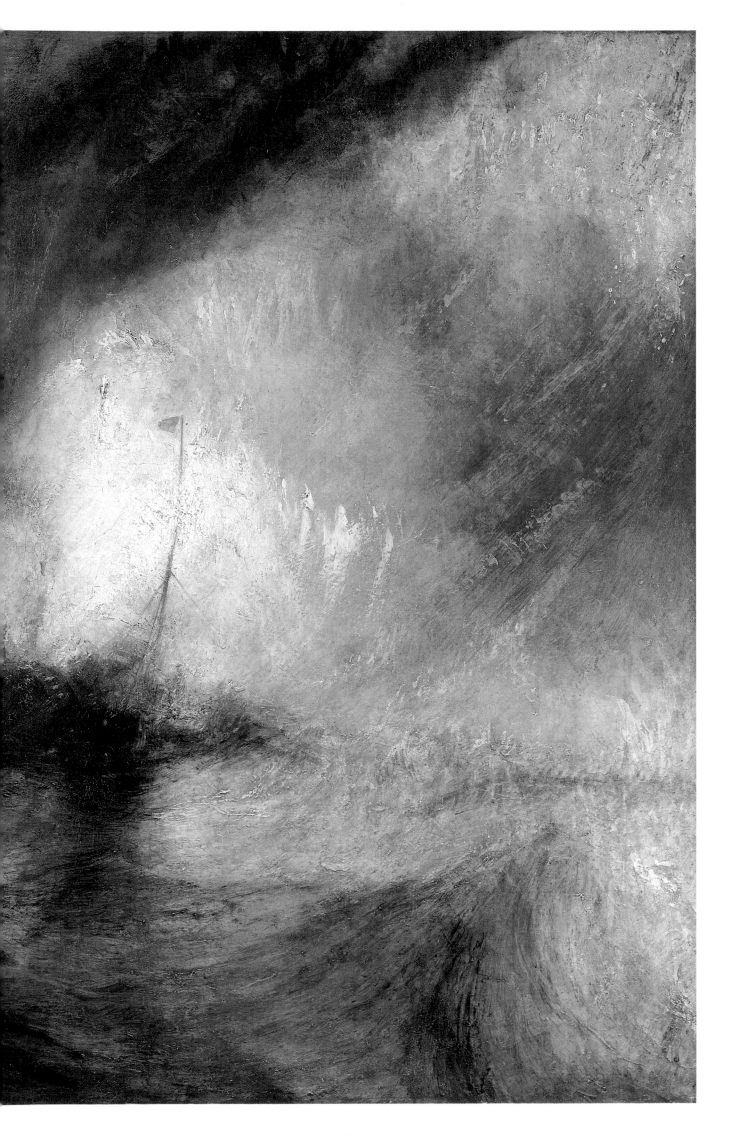

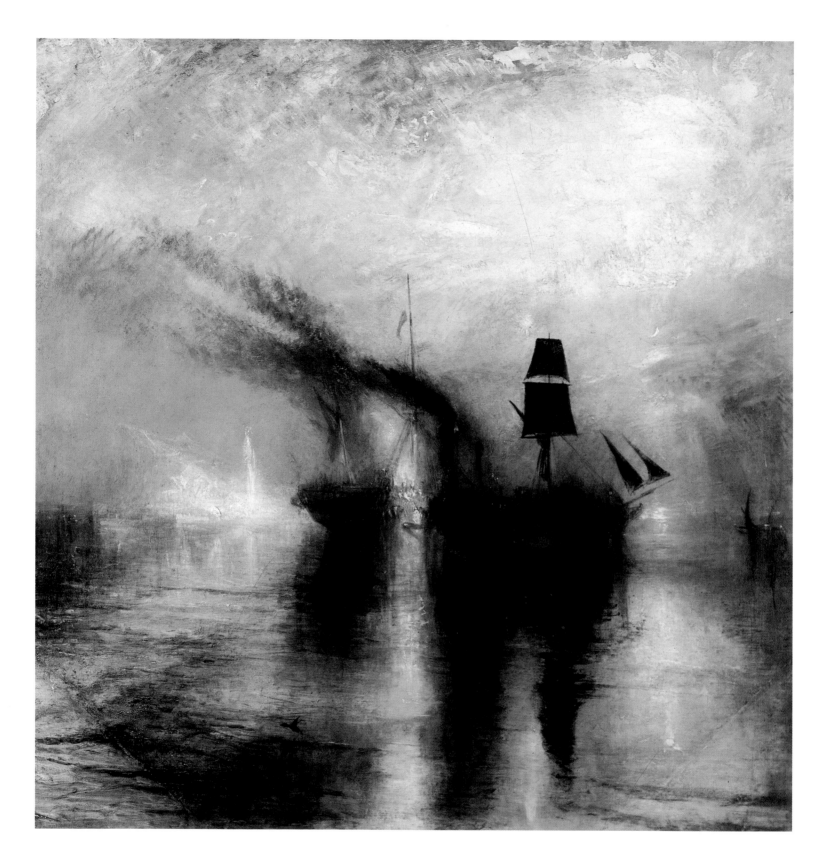

Peace – Burial at Sea, 1842
Oil on canvas, 87 x 86.5 cm
London, The Tate Gallery

The long title not only describes the painting's subject matter – which might otherwise be difficult to recognize – but is also in the nature of a justification. In elevating to the title the assurance that the event really did take place as depicted in the painting, Turner clearly reveals that he was interested not only in the depiction of some dramatic natural event but also in recalling an experience. This inevitably raises the question of the relationship between the portrayal of nature as experienced and its reality, especially in the light of this particular painting. It is impossible to separate even the superficial description from the purely structural characteristics of the painting. It is only as a result of small elements that one is led to see the entire structure as

actually depicting anything at all – and it is clearly impossible to say what every element observed in the picture actually depicts. The structure of this painting tends to dissolve the conceptions which it calls into being, so that the observer can maintain these for only a moment before having to form them anew.

Furthermore, the painter presents a surface structure such as may be compared with that of a *Colour Beginning*. He interprets the material structures either not at all or only in part. This does not mean that the picture is incomplete, merely that it leaves the interpretation of the elements in the picture almost completely to the observer: while it is true that such interpretations lead one's impression of the picture in a particular direction, they are no longer binding.

In contrast to this, the manner in which the picture is seen becomes all the more binding. It is not indirectly, via the identification of the bright and dark areas with waves and clouds, that the impression of turbulent motion results. Indeed, these are of themselves naturally as lacking in motion as only a painted surface can be. If one examines the manner in which the observer's gaze moves over the surface of the painting, however, then one grows aware of the tumultuous nature of the elements as they interact with each other across the expanse of the canvas, as if this nature possessed a life of its own. But it is not only the contrasts in brightness which achieve an effect. The aforementioned parallel brushstrokes capture the movement of the observer's gaze, directing and diverting it, steering it in this manner from the left edge of the painting to the dark area at the bottom, lifting it from there towards the centre, virtually slowing it down, before it then swings so much the faster in the direction of a point in which all the lines culminate; one could say that it is held up for a moment here, before falling downwards and shooting out over the border of the painting with a swing to the right. Furthermore, the described sequence of movement is immensely intensified through something highly unusual in the structure of contemporary pictures, namely the diagonal positioning of a line of horizon halfway up the painting, running from upper left to lower right. Pitching, the entire structure is tipping over, on the point of losing its balance.

The above remarks may suffice to alert the observer to the fact that the description of this movement of the eye as directed by the picture's structure is simultaneously the description of the movement of a wave. The same could be said of the cloud formations, the streaks of snow and rain, the play of the reflections in the water, and – not least – the pitching of the boat. It is not through the labels defining them but through the observer's active experience of them that the elements represented here receive meaning. The motion of the clouds and waves is not deduced from the "fixed position" of things in the painting – the raised crest of a wave, for example – as was the case in *Calais Pier* (pp. 26/27). The observer experiences the motion of things as his own observational activity.

The sweep of the waves; the whirling mass of snow, spray and rain; the raging forces of nature encircling the almost foundering ship – all this Turner experienced. He had himself bound to the mast by the seamen, who were already giving up the ship for lost, and watched the raging of the elements for over four hours. He empathized completely with the dynamic form of sovereign nature. Correspondingly, that which he created in his painting was no longer a mere reproduction. It was not the shape of things, nor the painting's composition, which produced this pictorial structure, but the character of the motion of the elements alone. If the observer follows the impulses and the directional force of these forms with his gaze, then he will directly participate in their life. Today's observer can no longer look over Turner's shoulder on varnishing day. However, he can become aware of the painting process through which the picture came into existence, for it is only through the movement of his gaze that the picture becomes that which makes it a picture, namely an effec-

War. The Exile and the Rock Limpet, 1842
Oil on canvas, 79.5 x 79.5 cm
London, The Tate Gallery

"Lost to All Hope the Brig. . ., c. 1845–50
Watercolour over pencil, 22 x 32.4 cm
New Haven, Yale Center for British Art, Paul
Mellon Collection

"Lost to all Hope she lies
Each sea breaks over a derelict (?)
On an unknown shore
The sea folk (?) only sharing (?) the triumph"

tive movement. The observer is no longer confronted with a "picture of" a "different" nature, one alien to the picture itself, in which a wave must seem "as if it were stone", since it cannot move in the picture. In looking at the picture, he experiences it as nature.

The same may be said of the famous painting *Rain, Steam and Speed – The Great Western Railway* (p. 2), from the National Gallery. Its upper areas reveal a fine interweave of scattered or more concentrated shades of yellow, which generally appear brightened in the extensive white area, although they are occasionally darkened through greyish-blue shading. Fine streaks lead one's gaze from the top diagonally to lower left, where it is brought to a halt, as it were, by the same shades of colour in a structure that is even denser if completely diffuse. Two heavy, black-brown, diverging straight lines appear out of this diffusion, their contours becoming ever clearer as they thicken towards the right-hand and lower edges of the painting. It is possible to interpret them as a bridge, along which the train is approaching. That this latter is represented in the picture is without doubt. Here, too, the vivid impression of rapid motion is due solely to the previously described observational movement. If one focusses one's gaze towards the centre of the painting, arriving there in the vicinity of the dark zone from which the train is emerging, then it is noticeable that one's eye is carried along almost forcefully by the lines, the speed increasing as they become clearer. This produces the direct visual experience of a rapid approach, its suggestive force being such as to create the impression that the train is moving at high speed. The speed of the observational movement and the motion itself are a reality experienced in the painting. These pictures reveal the logical consistency of Turner's search for the reality of nature in the picture.

"The most sublime thing cannot exist without the element of mystery."[28] That which Turner's critics were constantly reproaching him for was regarded by Ruskin even in the artist's lifetime as a chance for this style of painting. Whatever the extent to which man may grasp the boundlessness and magnitude of nature, it remains a puzzle for him. If Turner deviated in his pictures from the initial precision of his landscape portraits, his portrayal becoming increasingly "unclear", his subject-matter "darker", then Ruskin considered this no defect but rather the suitable form of expression for this world's unfathomability. That which is ambiguous brings about the wealth of aspects that renders the interpretation of the work of art so inexhaustible – like nature itself. Yet Turner's creations from the 1830s onwards were in part extreme, resulting in pictures such as apparently elude any definite interpretation.

We are not concerned here with those early "indistinctnesses" of outline which led to a clear pictorial definition of the atmospheric element, nor with the ephemeral contours, which strengthened the impression of potential movement for the things depicted in the painting – the boats on the Thames in *The Burning of the Houses of Lords and Commons. . .* (p. 42), for instance. First of all, the subject matter of a range of later works should be mentioned, the metaphorical sense of which cannot be resolved in an entirely conclusive manner. They only constitute a puzzle inasmuch as the solution is to be expected through the discovery of the correct associations of meaning. *War. The Exile and the Rock Limpet* (p. 73) is an example of such a picture and its quality of not entirely disclosing itself to the observer, one representing a total contrast to the hitherto characteristic developmental tendency. The allegorical element predominates, although it is not conclusive in the combination of almost symbolic figures and elements of meaning – Napoleon, the soldier, the sunset, the rock limpet.[29] Be that as it may, the counterpart to this picture, *Peace – Burial at Sea* (p. 72), painted as a tribute to David Wilkie, a fellow-artist, achieves a far greater effect through its directly observational character, as a result of the extremes of the fire's golden glow, on the one hand, and the black ships and sails, on the other. *The*

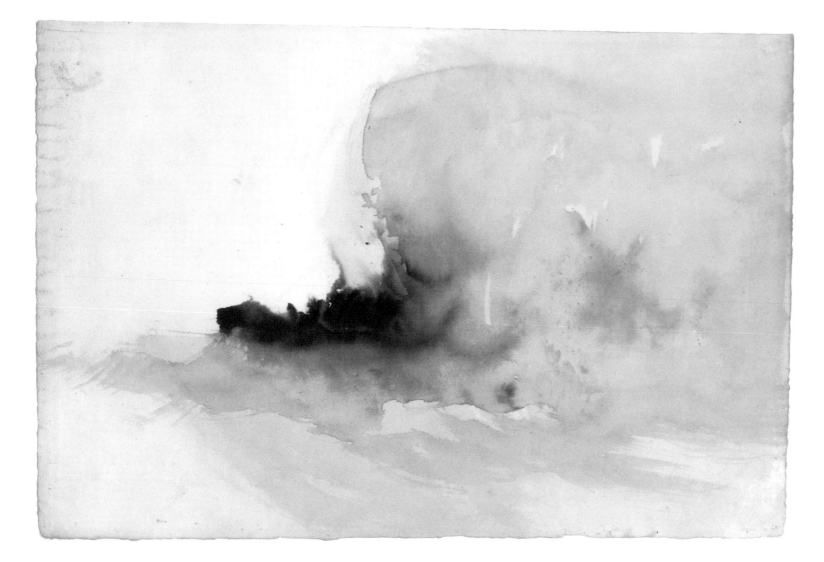

Angel standing in the Sun (p. 64) similarly creates the impression of an illustration for a metaphor. It seems to present in pictorial form a phrase of Ruskin's from the first edition of "Modern Painters", one so apocalyptic in its claim and tone that it was omitted from the second edition: Turner stands there "like the great angel of the Apocalypse . . . clad in a cloud and with a rainbow over his head and with sun and stars given into his hand".[30] Even such interpretations are neither certain nor exhaustive, however. Many of the motifs depicted here are still waiting to be deciphered.[31]

Those pictorial structures would appear to be of particular interest for an understanding of Turner's late style in which the nature of the representational content is either partly or entirely such that it cannot be definitively determined, while the structures themselves simultaneously attune the observer to the greatest extent possible to the process of becoming aware of representational values. They elude the observer. It is for this reason that they are hardly ever noticed.

The painting described as *Interior at Petworth* (pp. 80/81) initially seems to make possible an identification of a closed white room with gold ornamentation and a high arched portal in the wall opposite the observer. It could be that large windows on the right are darkened by means of yellow curtains or blinds, the room thereby appearing to be filled with a muted warm golden shade. In contrast, the adjoining room, visible through the arch in the centre, seems illuminated with dazzling brightness. The sun, coming into this room through the unveiled window, penetrates via the arch into the lower left-hand side of the room in which the observer is standing. Large mirrors can be discerned on the left-hand wall and to either side of the portal.

Ship on Fire (?), c. 1826–30
Watercolour, 33.8 x 49.2 cm
London, The Tate Gallery

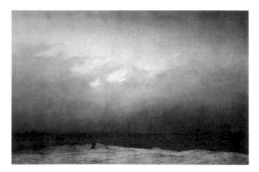

Caspar David Friedrich
The Monk by the Sea, 1808–10
Der Mönch am Meer
Oil on canvas, 110 x 171.5 cm
Berlin, Staatliche Museen Preußischer
Kulturbesitz, Nationalgalerie

They are recognizable through their high rectangular frames and the suggestion of transposed rectangular forms therein, together with differentiations of light and shade and colour-tones parallel to those visible in the room. In particular, the left-hand mirror directly facing the observer would appear to be reflecting a bright human form framed by a doorway, which leads to an adjoining, dark room. The observer's gaze is limited on the extreme right by a high curtain. The floor of the room appears to be full of various pieces of furniture: at least, a large Prussian-red baroque chest or bureau would appear to stand out on the right, along with a fireplace in the corner or a baroque armchair at the back on the extreme left. Larger objects may be made out between these – chests, baskets or upholstered benches, draped with large yellow and red sheets. Clothes and pieces of cloth and paper are scattered about. It also appears as if cats and small dogs are playing around in the general state of disorder.

It would of course be pointless to enumerate such depictive details if a list of this kind could be compiled with ease. This painting has also been seen as connected with the death of Lord Egremont. The object which was described above – not unintentionally – as a large baroque chest or bureau can also be interpreted as Egremont's sarcophagus,[32] it being this in all likelihood that first led to the association of this room with Petworth. Andrew Wilton also speaks of a "spot of white light in an open fountain", which is to be found – inexplicably – "behind" the coffin; on the other hand, he points out that no such central portal existed at Petworth.[33] The interpretation of the bright figure as the reflection of a human form standing in a dark doorway is equally uncertain; it could quite as easily be the reflection of a painting behind the observer's back. Moreover, it is unclear whether the right angle surrounding the figure really is a mirror, or rather an open door allowing one a view of further doors belonging to a suite. Nor is it even possible to ascertain the size of this room. If one calculates carefully the proportions of the "coffin" and the height of the room, one reaches the conclusion either that the room is exceedingly small, or else that the coffin is enormous. As it is, the scattered utensils and animals look tiny in comparison with the coffin or chest – that is, if we are in fact concerned with animals here at all: as depicted here, they can hardly function as a yardstick by which to ascertain the room's size – as is possible with a human figure in a landscape, for example. Are we actually looking at sheets and clothes and covered furniture at all? What is the object in the lower left-hand corner – a fountain, a fireplace, an armchair, or even a kneeling figure? Does the central arch lead to an adjoining room, or is it in fact a brightly illuminated apse? It makes no difference which concept one begins with. Each ascertainment that suggests itself when one takes an initial look at the painting is made relative when one looks again; each time one re-interprets one element, the overall interpretation is affected to a greater or lesser degree. The more one attempts to comprehend that which is depicted, the more this painting becomes incomprehensible, and that which one has thought to understand slips from one's mental grasp.

In this light, an attempt to understand the work might well be dismissed as a futile effort, yet this futility stems solely from the inadequacy of the interpretive conceptions. It is precisely this failure, however, which is the "content" of this painting – albeit a content revealing itself only to those who experience their own failure as a real process in the context of the picture. The lack of interpretation stems not from what is depicted in the painting but from the direct experience of the observer. The principle announced in the context of the depiction of the scene in *Regulus* (p. 54), that the picture's content is experienced through what is directly observable, applies here without qualification. However, the puzzling nature of such pictures affects not only their comprehension but also their observation. One can grow aware of the fact that the observational act is not content with producing meaningful elements for a comprehension of the picture. The reverse is true: the failure to understand leads

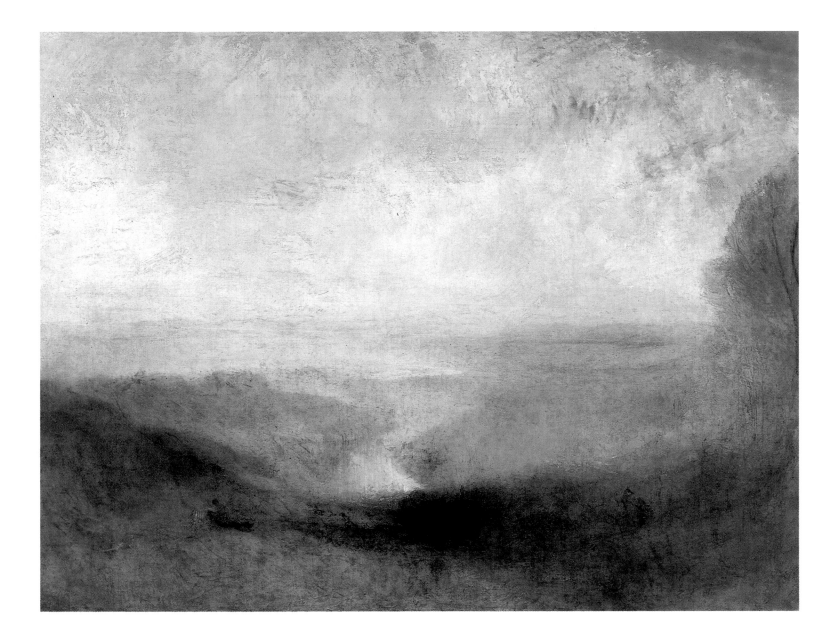

one to renew one's efforts, thereby taking one back again and again to the observational act too, in order to receive the impulse there for a new interpretation – a re-interpretation. If the picture is incommensurable with reality – as here – then this process can yield no result, and thus remains inconclusive. If it is a matter of comprehending the picture's effect, then this result is interesting solely inasmuch as it does *not* emerge; it becomes the driving element. The described process of interpretation and re-interpretation becomes important, renewing itself each time one looks again at the picture. In the light of such a structure, the observer can become conscious of the life taking place between comprehension and observation – a life in the intermediary world of this picture, where that which can be perceived by the senses does not point to facts but gives rise to ideas, where that which is to be suspected is unified in an alternating fashion with that which is observed.

Sunrise with Sea Monsters (p. 59) is another example of a picture where the interpretive process is open-ended. A restless, turbulent patch of open sea stretches into the distance under an extremely diffuse sky, the latter of a yellow that increases towards the horizon, the former almost reflecting the yellow of the sky, brightened with white in the background and brown in the foreground. Some apparently monstrous fishlike shapes, similar to those observed in *Slavers throwing overboard the Dead and Dying. . .* (pp. 90/91), are rising up out of the surface, agitating the water. One is

Landscape with a River and a Bay in the Distance,
c. 1840–50
Oil on canvas, 94 x 123 cm
Paris, Musée du Louvre

Detail from *Shade and Darkness – the Evening of the Deluge,* 1843
(cf. illus. p. 86)

struck by the two heads which have risen up the highest, by their staring eyes and half-open mouths. Some black lines in a crisscross pattern can be seen to the left of the bodies of the fish – the remains of a net, perhaps. Somewhat further to the left, a dog's head painted in pink may be made out, with the profile of a head apparently wearing a white mask above it, its eyes closed. One could take this for the head of a drowned man, were it not for the similarity with that of an animal. However, a more prolonged examination of the painting can give rise to further confusion, for example through the sense that the two aforementioned fishheads could combine with the oval with a touch of dark-red under them to form *one* large monster with open jaws and staring eyes facing forwards, swimming towards the observer as it spouts jets of water like a whale. This impression is strengthened in close-up (p. 56, bottom). It changes once again if one concentrates upon the mouth of the right-hand fish, for example.

The confusion caused by such conceptions and their constantly shifting interpretations permeates the sunrise atmosphere, which in general still gives the impression of a natural scene. It is not the liberating expanse of the sea, nor the familiarity of the growing light, but the incomprehensible and unfathomable strangeness of the interplay between the elements of water, air and light that intensifies between observation and understanding to create an atmosphere, a visionary life of its own, simultaneously real and unreal.

Turner's late landscapes are thus revealed to be seemingly imbued with a life of their own, no longer even affected by this shadowy fantasy-world. Spatial definition has become quite impossible in *Landscape with a River and a Bay in the Distance* (p. 77). Various shapes – hills, a valley, a tree, water, clouds – develop out of formations on the surface in gentle transitions and modulations of colour, and then reconstruct themselves. It is no longer possible to give anything – no matter whether pictorial or representational – a precise and indisputable definition. It is impossible to decide whether the central cleft should be taken as representing a stream in the immediate foreground, or a rocky valley in the distance seen from above, through which a broad, sparkling river flows. The certainty contained in the title is deceptive, for the background can also give the impression of a wide lowland plain full of haze and clouds – exactly as in the *Colour Beginning* examined earlier (p. 37). The world, as portrayed in the picture, is not what it is in reality but rather in a state of continual development, a never-ending process of creation, reconstruction, disintegration. The promise of the effect of nature in the picture is fulfilled. Turner did not exhibit these pictures, keeping them hidden even from Ruskin, who saw in them merely a waning of the artist's powers of creation, brought about through old age. Even Ruskin was unable to accompany the artist on this final step to the stage where the picture's effect is achieved purely through the observational act.

The watercolours and oil paintings from Turner's final years appear to increase the wealth of ambiguous elements, resulting in a potential observational experience of incomprehensible richness; simultaneously, however, Turner's late sketches display a contrasting capability to reduce things to the absolute minimum, albeit in such a way that the richness of the experience is not diminished but rather intensified to produce a form that is nevertheless open.

On the ninth sheet of the *Ideas Of Folkstone* sketchbook from 1845 (p. 68), even the colours are reduced to a bare minimum. The central section is dominated by two very large and powerful grey brushstrokes, which reach as far as the right-hand edge of the picture, where they simply break off. The lower of the two has been painted over the higher one, standing out from the latter both through the use of a darker shade of grey and in part through its sharper contours. Other small cubical elements have been inserted into the wet paint, both there and also underneath to the right in

the brightest shades of grey, from which an impression may be formed of mighty castle walls in the distance with a massive embankment in the foreground. The upper part of the picture is also covered with a grey wash; however, this is extremely fine, allowing a very fine blue and simultaneously a dissolving yellow-orange to show through. At the bottom of the painting, where one's conception of the picture would expect water and reflections, the colours are stronger, yet so blurred that a covering up of the powerful horizontal central element would make it impossible to identify anything. These colours have the effect of reflections in the water; however, the impression of representational forms remains purely subjective, stemming exclusively from *one* single shape seen in the context of the wide, almost shapeless areas of colour. The solidity of the fortifications and the expanse of the atmosphere are communicated directly through the intensity of the outlined grey together with the completely indefinite areas of colour, the latter thereby determining the atmosphere.

One other – final – example: the entire surface of *Boats at Sea* (p. 62) is covered with a layer of yellow and very bright pink. This shade simply becomes more intense roughly in the lower half of the picture, so that a horizon stands out slightly below the centre. There and there only do we encounter a red and a black brushstroke. Here, too, the impression is thereby created that only one element has been structured in an otherwise free space defined by colour. One's own experience would lead one to describe this as the impression that can be created by two boats on the expanse of a sea's surface. As a result of the constellation with the horizontal line described above, those parts of the red and black brushstroke lying beneath the line appear to be the reflection of those above it. On the other hand, it is through this mirror-image that the horizontal line becomes the sea's horizon. The one finds its interpretation in the other; alone, each would have no representational significance. Nevertheless, this so laconic form permits one to feel a sense of an infinite expanse, one which need not first be derived from a prior awareness of the connection between "sea's surface" and "boats". By means of the close proximity of its contrast, this red and black element binds the observer's gaze, which would otherwise lose itself in the surrounding amorphous mass. It is merely in the variation in intensity of the ground that the sense of an 'above' – "sky" – and a 'below' – "sea" – can be imagined; the emergence of a complete representation is precluded from the very beginning. To this extent, such pictures are also sketches, in the sense of something incomplete, something fragmentary. At the same time, however, they do also appear complete. After all, we also encounter the world as we see it in a pictorial manner – otherwise we could not see it – and every object reveals the form, the dynamic shape, by which it may be recognized. However, the dynamic shapes in the world as we see it, in visible nature as we encounter it, are also caused each time by chance; in contrast, Turner's reductional style in his pictures leads the observer's gaze to a dynamic form such as can be free from this element of coincidence. Through this reduction, he finds the dynamic shape which forms the basis of the relevant dynamic forms encountered in nature, leading in this sense to the relevant "archetype" of the dynamic forms as actually found in nature. Nothing more can be removed from it; nothing can be added. When the picture achieves this structure, it is not incomplete, even if pictorial norms would regard it as suggesting that the painter were not yet finished. In these pictures, observation and understanding are taken back again and again to the unfinished state of the beginning.

However, it is only when all of the artistic elements of formation such as have been individually characterized so far are seen in the context of the use of colour that Turner gives them a unifying sense. It is only in their interaction that Turner is able to use colour in a way corresponding to the particular laws of nature regarding the observation of colour.

"His life partook of the character of his works, it was mysterious, and nothing seemed so much to please him as to try and puzzle you, or make you think so: for if he began to explain, or tell you anything, he was sure to break off in the middle, look very mysterious, nod, and wink his eye, saying to himself, 'Make out that if you can.'"
DAVID ROBERTS

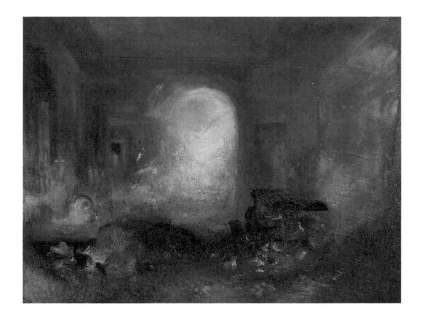

Interior at Petworth, c. 1837
Oil on canvas, 91 x 122 cm
London, The Tate Gallery

LEFT:
Detail from the above illustration

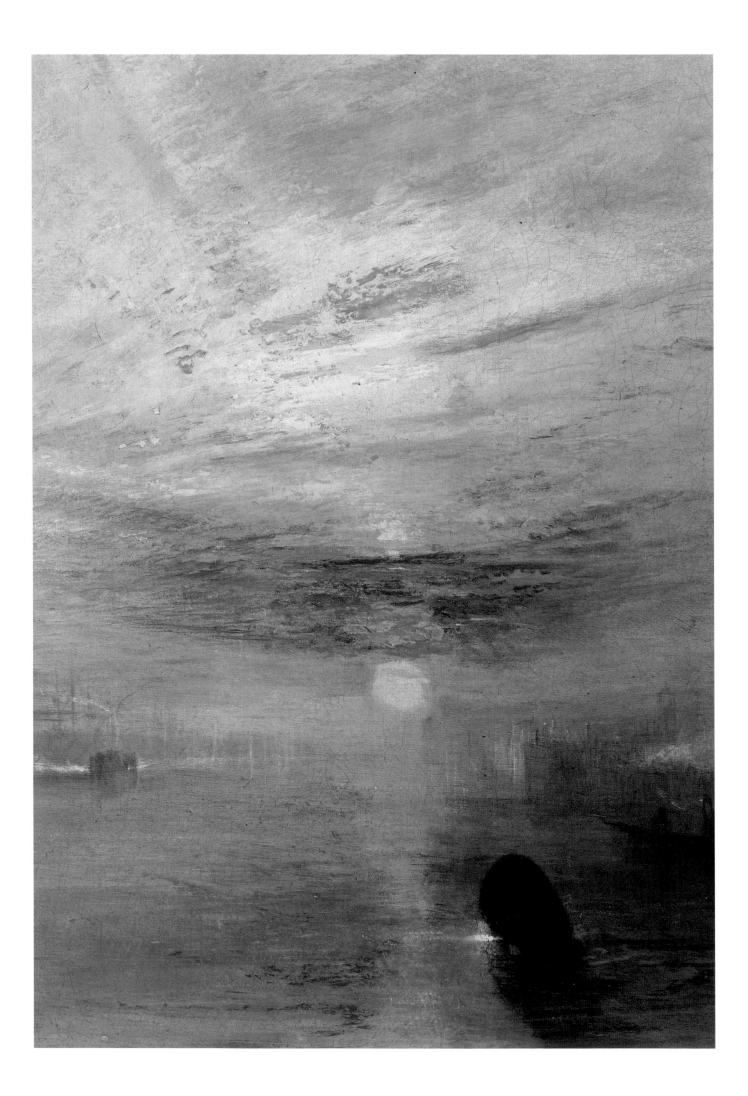

The "open secret" of colour

"My Darling", Turner called *The Fighting 'Téméraire' tugged to her last berth to be broken up, 1838* (p. 85). And indeed, the painting reveals many important and meaningful aspects of the artist's life – the decommissioning of the warship, for which there is now no further use, despite its having played a major part in winning the victory; the changing times, as the era of the machine commences; and others. At the same time, however, the painting signifies a climax in Turner's use of colour.

The painting could hardly be structured more clearly. It is executed almost exclusively in the primary colours of blue and yellow, together with their respective darker and lighter shades. The yellow, orange and red colours increase in intensity from the bright sun to the black of the boats on the far right, seen against the light and the dominant pictorial element of the bollard in the foreground. The darkening horizon brightens upwards into a blue colour, thereafter transformed into the pale white of the upper clouds. We encounter this constellation of polar colours again, reduced as if by a formula, at the steamer, on the water – to the left – and at the bright "Téméraire".

The phenomenon of colour was described by Goethe in his *Theory of Colours*.[34] A hazy area appears yellow when an area or source of brightness is behind it; as it intensifies, it turns orange, then red, until finally, completely intensified, it appears quite black. In contrast, a brightened cloudy area in front of a dark background appears blue, changing into violet when the appropriate source of brightness occurs. The effect of this latter is the only effect which is not used in this painting. The entire colour structure could almost be seen as an illustration of those characteristics described by Goethe for the manifestations of the basic blue-yellow polarity in the sun, the clouds, smoke and the blue sky.[35]

The key to understanding the great harmony of this painting lies in the subtle and yet varied interrelations of the ensemble of colours. It offers an entirety. The basic law of the appearance of colour is itself manifested. The whole pictorial world dissolves into colour. This cannot be found in such a way in a natural landscape; nevertheless, this regularity does work here, since the nuances of colour correspond to the tendencies encountered in nature. In the light of the largely conclusive pictorial impressions, the fact that we are concerned here with the aesthetic development of a law governing colour alone can be seen as of merely secondary importance.

The colours employed in *Slavers throwing overboard the Dead and Dying...* are almost identical with those found in *The Fighting 'Téméraire'. ...* However, the reds in the former have been intensified to an extensive yellowish-red, while the widespread yellow colour is heavily refracted throughout the painting. Goethe writes that one need only "fix a totally yellowish-red surface with one's gaze for the colour to seem as if it is actually boring its way into the eye. It produces an unbelievable sense of shock, an effect that also manifests itself in situations of relative darkness".[36] In con-

"§154. The sun, when seen through a certain amount of haze, presents a yellowish disc. Its centre is often bright yellow, the edges already turning red. In a situation where the air is filled with smoke (as was the case in the north in 1794, for example), and even more so with regard to the physical condition of the atmosphere in southern regions when the sirocco is blowing, the sun appears ruby-red, as do all the clouds surrounding it in the latter circumstances, which then reflect this colour. The red sky in the morning or the evening is due to the same cause. The sun announces itself to us via a red hue as it shines through a dense mass of mist. The further it rises, the brighter and yellower it shines."
(Goethe, *Theory of Colours*, HA, vol. 13, p. 363)

ILLUSTRATION PAGE 82:
Detail from *The Fighting 'Téméraire' tugged to her last berth to be broken up*, 1838
(cf. illus. p. 85)

trast, he characterizes impure yellow as a colour that causes considerable uneasiness. To be sure, the painting's "heroic" subject-matter, together with the accompanying lines, awake corresponding associations. However, the dreadful and shocking subject is presented in a manner that is not at all effective. It is first of all from the spontaneous direct effect of the aggressive colour pattern itself that the qualities of threat and catastrophe spring which can be felt so deeply here. In Turner's late works, it is the colour that becomes the scene of the action. The nature of what is being depicted in the picture can be experienced directly by the observer via the nature of the colour.

In characterizing Turner's colours, we have referred again and again to Goethe. In his final creative years, Turner was to make a thorough study of Goethe's theory of colours. Charles Lock Eastlake, a fellow-painter and friend, had translated Goethe's text, presenting Turner with it towards the end of 1843. Turner's copy of this book, with his laconic marginal comments, is still preserved today.[37] A quite separate survey would be required if we were to analyse Turner's relationship to Goethe's theory of colours; moreover, it would be necessary to make a general assessment of what might be termed the apocryphal history of the effect exerted by Goethe's theory of colours not so much on art theory as on the practice of art in the nineteenth century. All that is possible here is an indication of the extent to which Goethe's theory is indispensable for an understanding of Turner's late works. The main points can be summarized as follows. In the course of his creative life, Turner discovered for himself the regularities and the expressiveness of colour. To this extent, his attitude towards Goethe's text is quite superior and critical from a practical standpoint despite certain misunderstandings, which are, however, of an insignificant nature. The majority of the phenomena described by Goethe, in particular those concerning the use of colour, contain nothing that is new for Turner. He is primarily interested in that which he can put to practical use. His own thinking on colour is augmented by only a few fundamental aspects.

Goethe's theory was the only attempt in Turner's time to formulate a theory of the phenomena of light and colour acknowledging the physical, psychological and aesthetic conditions and their interrelation. As a concept of an introduction to the phenomenality of colour, it is a kindred spirit to Turner's creative work.

One of these marginal notes is a direct expression of the extent to which Turner was in accord with Goethe's opinions. At the same time, it shows that Turner was fully aware of the problematic nature, as examined here from various angles, of a pictorial quality aiming at direct experience through the observational act. With regard to the effect of colour structures in a picture, Goethe writes: "If the totality of colour is presented to the eye from the outside in the form of an object, it will be pleasing to the eye, because it thereby encounters the sum of its own activity as reality."[38] Turner comments: "- this is the object of Paintg [painting]."[39]

It is not in order to present a realistic depiction of the world in his pictures that Turner uses colour in his late works. His course turns out to be a gradual abandonment of realistic depiction. It is to the same extent that his colours approach that which was hitherto to be portrayed as the effect of nature within the picture. His late pictures develop out of the structural laws of colour, which can reveal their oneness with the effect of nature through the reality of observation. The observer experiences as reality his own observational activity within the effect of the nature of colour in the picture. After all, if anything in the picture is nature, then it is colour. It is made up of colour, each colour producing its own effect whether encountered in the picture or in nature. In appearing in the picture, it does not lose its natural effect. The nature of colour, formed in the picture, is the "open secret" of Turner's skill with colour.

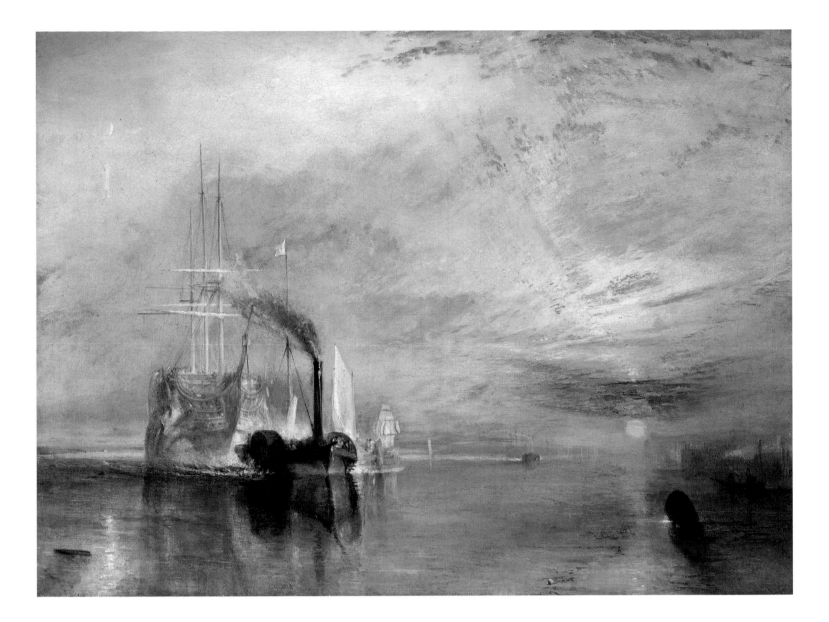

However, such a consideration would only appear sensible if we move away from the habit of thinking that nature can be present in the picture *in realistically depicted form*. Here again, it is Goethe who provided the necessary impulse. In describing a painted landscape, we easily forget that what is described there is *not* nature: that which the observer has before him has not been formed from organic or physical matter, as is the case with every thing in the living organism of a landscape, for example. What structures and organizes all that is visible in the picture – colours and shapes – what assigns each of them their individual position on the surface of the picture, can be nothing other than the acts of the artist. It is he who determines the arrangement of colours and forms in the picture – in accordance with his own understanding of the interrelation of things in the world as he sees it. A yellow blob in the picture is allotted its position on the surface of the picture by the artist – as is the sun in the sky by gravity. However, the realization of the relationship between sun and earth is simultaneously the realization of an interrelation, a law, an idea. And it is this that can give the artist the impulse to show a yellow blob as "sun" in an interrelation with other pictorial elements. Thus, he also structures the arrangements of representational things in the picture according to the "how", the conception of their interrelation. – And we may be certain that some possibilities are open here. – Goethe again: "It is precisely that which strikes uneducated people as nature in a work of art

The Fighting 'Téméraire' tugged to her last berth to be broken up, 1838
Oil on canvas, 91 x 122 cm
London, The National Gallery

85

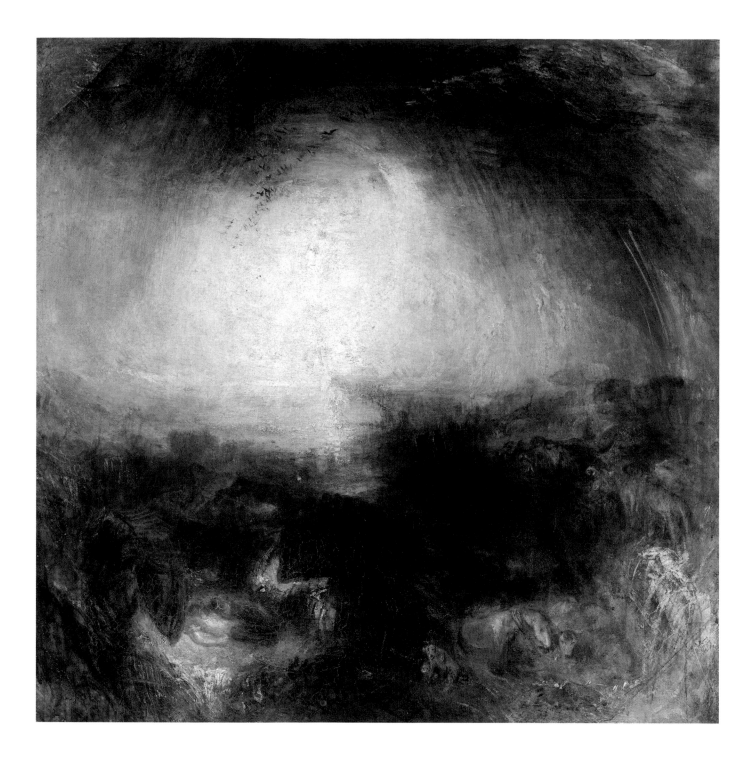

Shade and Darkness – the Evening of the Deluge, 1843
Oil on canvas, 78.5 x 78 cm
London, The Tate Gallery

The moon put forth her sign of woe unheeded;
But disobedience slept; the dark'ning Deluge closed around,
And the last token came; the giant framework floated,
The roused beasts forsook their nightly shelters screaming,
And the beasts waded to the ark.

Light and Colour (Goethe's Theory) – the Morning after the Deluge –
Moses writing the Book of Genesis, 1843
Oil on canvas, 78.5 x 78.5 cm
London, The Tate Gallery

The ark stood firm on Ararat; th' returning Sun
Exhaled earth's humid bubbles, and emulous of light,
Reflected her lost forms, each in prismatic guise
Hope's harbinger, ephemeral as the summer fly
Which rises, flits, expands, and dies.

Johann Wolfgang von Goethe
Colour circle, 1808–10
Farbenkreis
Frankfurt am Main, Freies Deutsches Hochstift,
Goethemuseum; sketched – possibly also col-
oured – by Goethe himself

"§155. If the darkness of endless space is seen
through an atmospheric haze illuminated by
daylight, then the colour blue appears. The sky,
as observed from high mountains during the
day, appears royal blue, since the quantity of
fine haze floating in front of endless, dark space
is but small; as soon as one descends into the val-
leys, the blue becomes lighter in hue, finally
turning completely into a white-blue in certain
regions and with increasing haze."
(Goethe, *Theory of Colours,* HA, vol. 13, p. 363)

that is not nature (from without), but man (from within)." – "In speaking of nature,
artists always imply something with this idea beyond that which is obvious to the
mind, without their being fully conscious of the fact."[40]

However, that which the artist receives and then includes from nature need not
be an idea in the purely abstract sense. With regard to form, the artist can be led by
the dynamic shapes characterizing things in nature. With regard to colours, he can
follow the laws governing their effect, as he has understood them through observa-
tion. The laws of nature and the laws of depiction show themselves to be connected
in the reality of colour.

This twofold aspect receives its complex expression in the pair of paintings
Shade and Darkness – the Evening of the Deluge (p. 86) and *Light and Colour (Goethe's
Theory) – the Morning after the Deluge – Moses writing the Book of Genesis* (p. 87).

These paintings also pose a puzzle, with regard to every aspect mentioned
above. Their titles would appear to stem from a belated process of interpretation on
the part of the painter. They are open configurations, in which neither form nor col-
our any longer follow realistic preconditions of representation. They open up an infi-
nite wealth of aspects, simultaneously reducing the whole to *one* concise statement in
each case. They, too, can be grasped only momentarily. They lead the observer in a
quite specific, never-ending, observational dynamic form, the coloured manifesta-
tion of which corresponds in one case to a reduction of colour, in the other to its un-
folded totality. The process by which one becomes aware of both the form and the
ensemble of colour is inseparably linked to the process of observation. In short, these
paintings may be considered the sum of the complete path of development taken by
Turner's art. It is for this reason that they appear sketchlike, as if uncompleted, allow-
ing of no end to the process of interpretation. It would be inappropriate to add a fur-
ther interpretation of these pictures to those attempts already available in the lit-
erature, for the present assessment could suggest that their message – if, indeed, there
is one – is not to be summed up in a concept that can be removed from the repre-
sentational process, in *one* statement. However, the path taken in the examination of
individual works in the present volume has perhaps resulted in attention being
drawn to those elements which are to be taken into consideration for an under-
standing of Turner's pictures. By developing one's observational skills when studying
the various qualities in his pictures, one can enable one's powers of observation to
open up those things which are ultimately beyond the reach of the mediating word
here. It is for this reason that the pictures included here, after only a few final com-
ments and indications as to particular points to look out for, will ultimately be left to
the observer.

The paintings have been conceived as a pair. The subject-matter takes up the
heroic landscape of Turner's early years and the customs common in the mid-nine-
teenth century. The treatment of the subject in its square format is without prece-
dent. The corner spandrels, which give the sector the form of an irregular octagon,
are original Turner. It may well be that the colours are very dull and dark in com-
parison with their original state when freshly painted. The shades of blue and the yel-
low colour would appear to have suffered particularly severely.

Shade and Darkness – the Evening of the Deluge (p. 86): The painting's greatest ef-
fect stems from its light-and-dark structure. The dark areas of greatest density may be
found slightly under the centre and at the top edge, this second area spreading out to
right and left like a wide arc, down into the bright colour. The brightest point, inter-
spersed with bright blue shades, is located under this arc, and is surrounded by a halo
at an appropriate distance, although the latter does not form a closed circle. At lower
right, the surface is lit in pale yellow; on the left, accents of strong white and clearly
visible red appear around the brightest shade of yellow in the painting. No point of-

fers the observer a firm point of reference; his gaze is caught as little by the centre of brightness as by the centre of darkness below it, split into two parts. Even the small forms interspersed throughout the large structure do not consolidate anywhere, achieving more or less clear outlines merely through the general light-and-dark structure. Any attempt to identify them individually results in their disappearance. It may be noticed, however, that the observer's gaze is especially drawn time and again within the blurred weave by certain larger zones, is directed in a particular manner from zone to zone. Within the lower area of the painting, his gaze is led back and forth again and again from the one bright zone – on the left – to the other – on the right. Yet this movement is not without resistance; his gaze must to a certain extent force itself through the confusing mass of small structures, each of which seeks to isolate itself from the rest of the painting. Direction is lost time and again. If the observer's gaze sets forth from the upper edge of the picture, then it is pulled away along the sides to the bottom. Even here no general movement encompassing the entire picture takes place: although the necessary impulse would appear to have been given in each case, it always fades away. The observer's gaze plunges whenever the movement starts at the top. It becomes entangled in the lower part of the picture in the almost impenetrable weave of dissolving, most different formations. Taken as a whole, the entire structure reveals a tendency towards disorientation, dissolution, disintegration.

A more prolonged observation causes the bright areas to become darker, in accordance with the afterimage effect. However, it is not the case that the dark zones become perceptibly brighter to an equal extent; rather, it is as though the entire painting were constantly becoming ever-darker.

An oblong shadow can be seen near the geometric centre of the picture, one which could be interpreted as the Ark, seen from far away. A procession of animals appears to be making its way in that direction. An impression of great spatial depth results, corresponding to a perspective tapering of this procession, which is accompanied from the left by the line of a riverbank. In contrast, the foreground at the lower edge of the painting appears to fall into the surface of the painting before the observer's eyes; it is only through the outlines of the animals there, an attempt at the identification of which can be made and which seem large in comparison to the blurred, ever-diminishing outlines in the middle zone, that the solid geometry of the foreground too can be re-established. The centre of brightness described above should be imagined as lying furthest away within the spatial dimensions portrayed; if one's gaze stops in this zone for a time, however, it advances inexorably across the picture. It is only the succession of clear dark brushmarks projecting into this zone from above – interpreted as birds – which allow it to appear once again as if it were *behind* the dark zone above it: any spatial conception inspired by what is depicted is simultaneously cancelled by the effects of the formations observed in the painting.

The small structures in the lower right-hand quarter of the painting are predominantly the outlines of animals. However, none of these outlines is quite complete; each one merges gently into its surroundings, a tendency that increases in the case of those animal forms to be thought of as more distant. It is only in the foreground that the outlines take on form to any extent, only there that we see what we can call dogs, horses, cattle. Further back, in contrast, any possibility of identifying particular animals is lost – indeed, it is only on account of the identification of similar forms in the foreground that these forms can be described as those of animals; moreover, it is no longer even possible to distinguish here between the animals and the space between them. Put another way, even the gaps between these diffuse individual forms take on an animal-like form. A process is initiated whereby one ultimately tries to find the shape of an animal in all the forms within this area: the physical ani-

Colour circles
Watercolour
London, The British Museum

mal-shape is in the process of dissolving. The only thing that remains is the constantly self-renewing tendency towards formation in animal form. It is this that can survive in the "Ark".

Are we looking here at the sun, darkened by the dense bands of rain, or at the moon, as mentioned in the lines of poetry? How is it possible for the sea's horizon to bend upwards to right and left? What is land with cliffs and trees at the left edge of the painting, and what sea? Rushing, torrential water may be recognized on the left and in the very foreground. Everything is crisscrossed with rivers and streams. Nowhere does it become clear either whence the water has come or whither it is flowing. At lower left, it is also overflowing forwards – somehow – out of the interior of a destroyed house or a collapsed tent in shreds. At first glance, it could seem that a half-naked human couple is lying upon the bright yellow ground. On closer inspection, however, this impression disappears in confusing fashion, the limbs become isolated, and it is unclear whether it is not in fact a question of only *one* figure – or maybe even three – lying there. The bright inclusions above to the right similarly lose definition upon a more detailed examination, and the border between the "ruin" and the landscape vanishes. Everything retains more than one interpretation, while that to which one can nevertheless give an interpretation constantly vanishes. The observer grows aware, not of how forms are created, merely of their tendency to dissolve.

Light and Colour (Goethe's Theory) – the Morning after the Deluge – Moses writing the Book of Genesis (p. 87): The colours determine the character of the painting as a whole. Yellow, glowing strongly on the left, increases in brightness towards the white centre; orange and red, as if drawn in a circle through the entire format, are intensified at the very bottom on the left almost to black; blue takes on a gradually cooler hue from the upper right-hand corner to the white centre; green intensifies in the dark area under the centre. The entire colour circle is present. However, the colours do not occur in the fixed order of the colour circle; rather, they merely intensify here and there, remaining connected in each case with their surroundings: there is only a suspicion of the individual colours themselves. Their order is not already established; it is in the process of formation. This order, the law of light, the colour circle, the "rainbow" as symbol of reconciliation, is to be comprehended in this constellation of colour as *in statu nascendi*.

The treatment of the areas reveals an extensively uniform structure. As in *Snow Storm – Steam-Boat off a Harbour's Mouth. . .* (pp. 70/71), the fine brushstrokes in the same direction, which resemble those of the earlier picture, exert a considerable influence upon the direction of the observer's gaze. If it starts out from the centre towards the upper left, then it follows a general form encompassing the whole picture, which leads out of the format at lower left. A movement results in the sense of an expanding circle, often referred to before as a "whirling" movement. The stimulus to move in the opposite direction would seem even more powerful: the observer's gaze is led from the lower-left edge towards the right, from the dark area into a zone that becomes ever brighter, there to pause in the central sphere. This movement is characterized by the tendency towards an increase in brightness.

In performing such movements, the observer's gaze passes through the various areas of colour on the surface of the painting. If one starts with the most intensive yellow, orange and red follow; then blue, abruptly isolated in the upper right-hand corner and facing the most intensive yellow; then bright yellow again, orange, red, and black. The central zone of green, the secondary colour from blue and yellow, does not lie within the circle: the "original contrast" of the creation of colour, yellow and blue, face each other in this pattern of movement. It is out of this contrast that every colour emerges ("Goethe's Theory"). Colour does not merely depict col-

ILLUSTRATION PAGES 90/91:
Slavers throwing overboard the Dead and Dying – Typhon coming on ("The Slave Ship"), 1840
Oil on canvas, 90.8 x 122.6 cm
Boston, The Museum of Fine Arts, Henry Lillie Pierce Fund

"Aloft all hands, strike the top-masts and belay;
Yon angry setting sun and fierce-edged clouds
Declare the Typhon's coming.
Before it sweeps your decks, throw overboard
The dead and dying – ne'er heed their chains.
Hope, Hope, fallacious Hope!
Where is thy market now?"

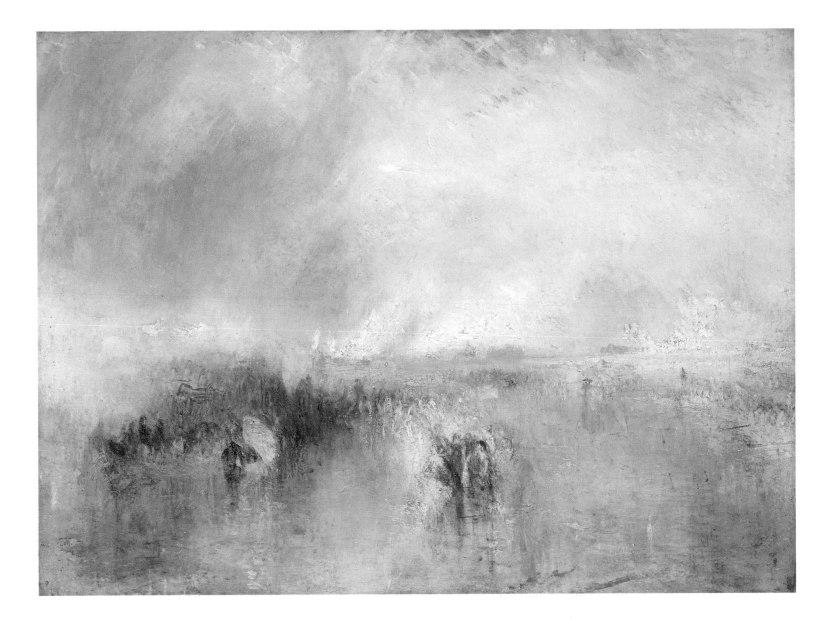

our. Colour *is* colour. Wherever colour can appear in pictorial form in accordance with its own laws of manifestation, there it reveals its nature as reality.

In the middle of the painting may be seen the fine depiction of a serpent raised up. Above it, floating freely in the white field, is the form of Moses, mentioned in the painting's title. Apart from the suggestion of green mountains in the centre and the skeletons of fish at lower right, these are the only formations depicting objects that appear – at least partly – determined. They do not disappear in the general process of movement. Even if the significance of the serpent and the skeletons – and, even more so, that of the floating form of Moses – remains open to interpretation, the shapes of these figures endure within the movement of the picture: the law is form – permanence in change.

The entire lower edge is filled with what can be taken to be human forms. Many small faces, shoulders, arms, occasionally finely depicted bodies, emerge from the light of their surroundings, as if themselves lit up. Small spheres are portrayed around some of the heads – small-form versions of the large picture as a whole. It is impossible to determine how far towards the upper left this floating, constantly forming structure of human shapes remains recognizable. As with the colours, so it is with the forms, revealing themselves in the process of genesis: The manifestation of the world may be experienced in Turner's painting – as the world of light and colour.

Procession of Boats with Distant Smoke, Venice,
c. 1845
Oil on canvas, 90 x 120.5 cm
London, The Tate Gallery

J.M.W.Turner 1775–1851: Chronology

1775 Born in Covent Garden, the son of William Turner, a barber and wig-maker.

1787 The first drawings.

1789–90 Turner produces his first sketchbook. Commissions for drawings from various architects. Work and study under Thomas Malton. Admitted as student of Royal Academy Schools. Exhibition of first watercolour.

1793 Summer – drawing tour of South Wales; will spend some part of almost every year travelling for the rest of his life. Royal Academy award.

1794 Original pictures for engravings. Turner becomes famous as a topographical draughtsman.

1796 The first oil paintings.

1799 Various works, including studies after old masters. Claude Lorrain's paintings in the Angerstein Collection have the greatest effect upon him. Elected Associate Member of the Royal Academy.

1801–2 Tour of Scotland. First tour of Switzerland; study of pictures in the Louvre. Sketches and paintings as designs for the "Liber Studiorum". Elected full member of Royal Academy.

1803 Debates over Turner's conception of art begin.

1804 Turner opens his own gallery. Death of his mother; his father takes over the running of the artist's household.

1807 First volume of "Liber Studiorum" published. Elected Professor of Perspective at Royal Academy.

1809 Summer spent at Petworth.

1811 Illustrations to Cook, Byron and Scott in the following period. First lectures on perspective.

1817 Journey along the Rhine. First *Colour Beginning*.

1818 Autumn tour of Scotland.

1819 First visit to Italy: Turin, Como, Venice; stay in Rome and Naples; return home via Florence.

1821 Tour of France – Paris, Rouen, Dieppe – for illustrations to *Rivers of France*.

1822 Reopening of Turner's gallery (Queen Anne Street), meanwhile enlarged and expanded.

1825 Second Rhine journey.

Self-portrait, 1791
Watercolour touched with white, 9.5 x 7 cm
London, National Portrait Gallery

Charles Turner
A sweet temper, c. 1795
Pencil
London, The British Museum

George Dance
Turner, 1800
Pencil
London, Royal Academy of Arts

1828 Second visit to Italy. *Regulus* and other pictures exhibited in Rome, Turner framing his pictures with thick ship's rope. The exhibition meets with incomprehension. Contact with the German 'Nazarenes'.

1829 Death of Turner's father. The artist writes a will in which he makes over a part of his bequest to a foundation for landscape painters without means.

1830 Increasingly in Petworth over the next seven years – until the death of Lord Egremont – where a studio is always available to him. Following his father's death, Petworth – along with his contact to Royal Academy colleagues – becomes Turner's sole source of social contact: angling, hunting, country outings, musical occasions, parties, conversations about literature and art.

1835 Second stay in Venice, travelling there via Berlin, Dresden, Prague and Vienna.

1837 Resigns Royal Academy lecture post.

1840 First meeting with John Ruskin (1819–1900), whose sensational five-volume work, "Modern Painters", is the first to offer interpretive access to Turner's painting. Last stay in Venice. Eastlake presents him with a copy of his translation of Goethe's "Theory of Colours" (*Farbenlehre*).

1841 The years that follow see further visits to Switzerland, together with a journey to northern Italy and the Tyrol. This results in the cycle of late Swiss watercolours.

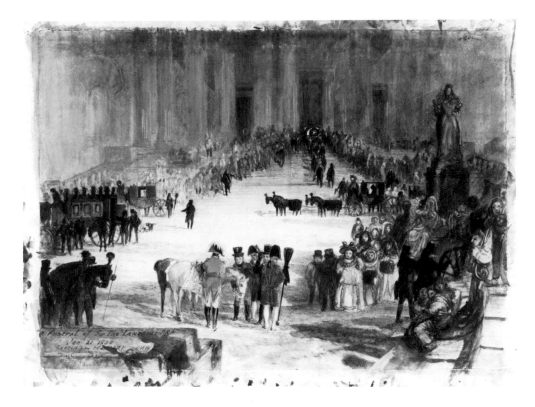

1845 Brief visits to France in spring and autumn – Turner's last trips abroad. Deterioration in health. Appointed Royal Academy auditor as eldest member.

1850 Last exhibition in the Royal Academy.

1851 Turner dies on 19th December in his house in Chelsea. Solemn burial in St.Paul's Cathedral.

Funeral of Sir Thomas Lawrence, a Sketch from Memory, 1830
Watercolour and body colour, 61.6 x 82.5 cm
London, The Tate Gallery

John Linnell
Studies made during Turner's lecture on Perspective, 1812
Pencil
London, The Tate Gallery

J.T.Smith
Turner in the Print Room of the British Museum, 1830–32
Watercolour, 22.2 x 18.2 cm
London, The British Museum

Count D'Orsay
Turner at a Conversazione of Elhanan Bicknell, 1850
Chalk, 26 x 16.5 cm
Private Collection

Notes

1 Ruskin, John, The Elements of Drawing (1857), in: Ruskin, John, The Works, 34 vols., E.T.Cook and A.Wedderburn (eds), London 1903–12, vol. XV, p. 27.

2 Wilton, Andrew, The Life and Work of J.M.W.Turner, XXX 1979, p. 220, and Wilton, Andrew, Turner in his time, London 1987, (Wilton, 1987a), p. 232: Rawlinson, W.G., The engraved Work of J.M.W.Turner, 2 vols., London 1908, p. 445, comment quoted after Wilton 1987.

3 Regarding this and all further details, cf. the extensive and definitive documentation by Andrew Wilton, London 1987. The sources for biographical details, anecdotes and rumours are the works of Thornbury, Walter, The Life of J.M.W.Turner, R.A., 2 vols., London 1876 [2], and Finberg, A.J., The Life of J.M.W.Turner, R.A., Oxford 1939, 1961 [2].

4 Cf. Bockemühl, Michael, Innocent of the Eye and Innocent of the Meaning. Zum Problem der Wirklichkeit in der realistischen Malerei von Gustave Caillebotte (A discussion of the problem of reality in Gustave Caillebotte's realistic painting), in:

Modernität und Tradition, Festschrift für Max Imdahl zum 60. Geburtstag, Gottfried Boehm, Karlheinz Stierle, Gundolf Winter (eds), Munich 1985, pp. 13–36.

5 Cf. Wilton, in: Bock, Henning, und Prinz, Ursula (eds.), J.M.W.Turner, der Maler des Lichts (The painter of light), Berlin 1972.

6 1648, National Gallery, London.

7 Gage, John, Colour in Turner. Poetry and Truth, London 1969.

8 In this scene, for example, the rules of du Fresnoy, upheld as ever in the Academy – here it is a question of the "Repoussoir effect" – are demonstrated through the painting.

9 Cf. Wilton, 1987a, p. 59

10 Ibid.

11 Ibid.; p. 68f.

12 Cf. Novotny, Fritz, Cézanne und das Ende der wissenschaftlichen Perspektive (Cézanne and the end of the scientific perspective), Vienna 1938.

13 Quotation after Wilton, 1987a, p. 73.

14 Ibid.; p. 35.

15 Ibid.; p. 85.

16 Ibid.; p. 64ff.

17 Cf. Hofmann, Werner (ed.), William Turner und die Landschaft seiner Zeit (William Turner and the contemporary landscape), Hamburger Kunsthalle, Hamburg and Munich 1976.

18 Wilton, 1979, p. 82.

19 Cf. Wilton, 1987a, p. 66.

20 Wilton, Andrew, Turner Watercolours in the Clore Gallery, London 1987 (Wilton, 1987b).

21 The self-portrait in the Turner Collection is the most representative of all the early attempts.

22 Cf. Lindsay, Stainton, William Turner in Venedig (William Turner in Venice), Munich 1985 [2].

23 It so happened that Prince Albert delivered

his first speech before an assembly of the Anti-Slavery Society during the exhibition of this painting. Cf. Wilton 1979, p. 219.

24 Goethe, Farbenlehre, Hamburger Ausgabe vol. 13, p. 495, §763.

25 Ibid.; p. 497, §777.

26 Ibid.; p. 498, §783.

27 Cf. Ruskin, loc. cit., vol. XIII, p. 161.

28 Cf. Ruskin's chapter "Of Turnerian Mystery", ibid., vol. IV, Part V.

29 Cf. McCoubrey, John, War and Peace in 1842 – Turner, Haydon and Wilkie, in: Turner Studies, vol. 4, No. 2, London 1984, p. 4.

30 Ruskin, loc. cit., vol. III, p. 254, footnote. Cf. also Wilton, 1979, p. 226, footnote 18, and Lindsay, Jack, J.M.W.Turner. His Life and Work. A Critical Biography, London 1966, p. 213.

31 Cf. Smith, Sheila M., Contemporary Politics and "The Eternal World" in Turner's Undine and Angel standing in the Sun, Turner Studies, V, No. 1, London 1986, pp. 40–49.

32 Cf. Wilton, 1979, p. 210f.

33 Ibid.

34 Cf. Goethe, loc. cit., vol. 13, p. 367f.

35 Cf. ibid.; p. 363.

36 Ibid.; §776, p. 497

37 Cf. the reprint of those sections marked and commented upon by Turner in: Gage, loc. cit., pp. 34–52, and Gage, John, Turner's Annotated Books: "Goethe's Theory of Colours", in: Turner Studies, vol. 4, No. 2, London 1984, Chapter 11.

38 Goethe, loc. cit., §808, p. 502.

39 Cf. Gage, 1984, p. 48.

40 Goethe, Schriften zur Kunst, Die Preisaufgabe betreffend (Writings on art, concerning the prize competition), Part 5, quotation after the Artemis edition, vol. 33, Nördlingen 1962, p. 212.

The particulars of the pictures follow the catalogue by Wilton, 1979, who refers back to the index of works compiled by Butlin and Joll, 1977. The date given refers to the first exhibition of a picture.

The publishers would like to thank the museums, galleries and photographers who supported us in the production of this book. We are especially grateful to the Tate Gallery for extremely helpful co-operation. In addition to those persons and institutions named in the legends to the pictures, the following deserve mention: John Webb (p. 7, 15, 19, 21, 24, 25, 31, 55, 59 bottom, 63, 64, 70/71, 73, 80/81, 86, 87, 93); © 1991 Indianapolis Museum of Art (p. 18); The Bridgeman Art Library, London (p. 34, 69); John R. Freeman & Co. Ltd., London (p. 32, top); Bildarchiv Preußischer Kulturbesitz, Berlin (p. 76); © Photo RMN (p. 77); Ursula Edelmann, Frankfurt am Main (p. 88). Reproduced by Courtesy of the Trustees, The National Gallery, London (p. 2, 22, 23, 26/27, 53, 85). Reproduced by Courtesy of the Trustees of the British Museum, London (p. 20 bottom, 29, 34, 89, 94 centre, 95 lower left). © 1991 VG Bild-Kunst, Bonn for p. 36 (Mark Rothko).